MURDER *of a* HERKIMER COUNTY TEACHER

MURDER of a HERKIMER COUNTY TEACHER

The Shocking 1914 Case of a Vengeful Student

DENNIS WEBSTER

Published by The History Press
Charleston, SC
www.historypress.net

Copyright © 2017 by Dennis Webster
All rights reserved

First published 2017

Manufactured in the United States

ISBN 9781467136457

Library of Congress Control Number: 2016956930

Notice: The information in this book is true and complete to the best of our knowledge. It is offered without guarantee on the part of the author or The History Press. The author and The History Press disclaim all liability in connection with the use of this book.

All rights reserved. No part of this book may be reproduced or transmitted in any form whatsoever without prior written permission from the publisher except in the case of brief quotations embodied in critical articles and reviews.

This book is dedicated to the compassionate people who devote their lives to assist those who have mental disabilities. These individuals give their love and care to those who struggle but strive to live a purpose-driven life. They care for those who have all ranges of mental challenges.

It's to these angels of God that I dedicate this book.

Contents

Foreword, by Susan R. Perkins — 9
Author's Note — 11
Acknowledgements — 13

1. The Village of Poland, Town of Russia and Herkimer County — 15
2. The Crime — 19
3. Major Players in the Murder and Trial — 27
4. Stenographer's Transcript of the Trial — 47
5. The Jury — 99
6. Chester Gillette Connection — 105
7. Jean Gianini Goes to Matteawan — 109
8. The Criminal Imbecile — 113
9. The Binet Scale — 119
10. A Modern Look — 123
11. The Poem — 125
12. Forgiveness — 129

Bibliography — 135
Index — 139
About the Author — 143

Foreword

Dennis Webster has authored several books, his most recent *Haunted Old Forge*. He has been a friend of the Herkimer County Historical Society through the years.

This book is a factual account of the murder of schoolteacher Lida Beecher by Jean Gianini on a cold winter day, March 27, 1914, up on Buck Hill Road in the village of Poland, New York. Dennis has taken the testimony of Jean's father, Charles Gianini; friends; fellow students; bosses; doctors; coroners; and the sheriff and has masterfully woven the story together. This was the first time during a murder trial that the Binet Scale was allowed to be used to measure a person's intelligence. The ramifications of the "Trial of the Century in Herkimer County" have been vast and deep, and the citizens of our area still whisper of it today, but it needs to be better known. The murder of Lida, the trial and the verdict should be taught and known. I'm pleased Dennis is placing the facts of this case out there, as it will benefit not only the people of Herkimer County but the entire country as well. The results of the trial were a wounded yet forgiving Beecher family and a Gianini family mourning the airing of their family secrets. Jean would spend the rest of his life in mental health institutions.

—Susan R. Perkins

Susan Perkins has spent most of her life in Dolgeville, New York. She graduated from Ithaca High School and Cazenovia College with an associate's degree in museum

Foreword

studies. Susan has been with the Herkimer County Historical Society for thirty-three years, the last twenty as the executive director. She has coauthored with Herkimer County Historical Society administrative assistant Caryl Hopson four Images of America Series on Herkimer, Frankfort, German Flatts and Little Falls. Since 1991, she has been the town of Manheim historian.

Author's Note

I had been inside the Herkimer County Historical Society many times for research, historical talks or to walk the historical museum in the Suiter building. It was during these times that I formed friendships with Sue Perkins and Carol Hopson. During research for other projects, the ladies kept asking me to write a book on the true story of the Lida Beecher murder and the trial of her accused killer, Jean Gianini. The more I looked into this case, the more I wanted to write the book. It was a sad tale all the way around, with a beautiful and sweet young schoolteacher murdered and a young man who would be deemed an "imbecile" condemned to spend the rest of his life in a psychiatric center for the crime he was acused of committing. But it was what happened outside of the crime that would forever change the way those with mental illness would be tried in the United States. It was the first time in our country that the Binet Scale would be allowed in court and end up ultimately keeping a mentally ill teenager from being put to death in the electric chair. The Binet Scale was a measuring of the mental age of children who had committed crimes or were deemed to have a mental disability. Some would call it a specialized IQ test.

The entire affair had raw emotions on both sides of the families and from within Herkimer County, the town of Russia and the village of Poland. Outside immediate family, is there a bond that is stronger for a child than that with his beloved schoolteacher? In the early twentieth century, when Jean Gianini murdered his teacher, Lida Beecher, most towns as small as Poland, New York, had a one-room schoolhouse that accommodated children from

Author's Note

kindergarten right through high school seniors. The smallness brought closeness and importance to that of the woman who had been chosen to teach the town's children. Back then, the term "normal school" was in fashion, and most teachers remained unmarried spinsters if they hoped to make a complete career out of teaching. The pay was usually low, and these young ladies often felt the profession as a calling, much like preachers or priests. Lida Beecher came from a very religious family, and the stunningly beautiful young woman fit right in with the Poland community. Her death, and the subsequent trial, would be one of the most controversial, groundbreaking and unusual in the history of the United States court system. Legal insanity for criminals would be tested in new ways, with the world's best alienists storming a packed courtroom in Herkimer, New York.

In many ways, the murder of Lida Beecher and the trial of Jean Gianini ushered in a new America where students could murder their teachers and get away with the crime. But it would also usher in a new era of sympathy for those who are pained and afflicted with mental illness that compels them to go against the norms and folkways of a civilized society. The Beecher family, with their preacher head of the family, struggled to forgive, while the members of the well-respected Gianini family struggled with the aftermath of a most heinous crime committed by their young brother and son. The village of Poland, the families, the prosecutors, the jurors, the law enforcement officers and the alienists would never be the same after the trial of the century in Herkimer County concluded.

I approached this book with an open mind and heart with a goal to report the facts and give a fair report to all who were involved and those descendants of both families still alive today. Perhaps the lives of Lida and Jean would not have been wasted if lessons could be learned for the benefit of those afflicted with mental illness and, perhaps, one measure of sympathy and understanding could be attained.

Acknowledgements

There are many wonderful people and good friends who assisted and guided me in the creation and writing of this book. Without the following family, people and organizations, this book would not have been possible: Andrew Buffington, June Campanaro, Nicole MG Fleming, the Herkimer County Historical Society, Caryl Hopson, Amanda Irle, Paula Johnson, Bernadette Peck, Susan Perkins, Poland Public Library, Town of Russia, Seth Voorhees, Charlene Webster, Evelyn Webster, Milton Lee Webster and www.inmatesofwillard.com. Thank you to The History Press for giving this book a home.

Chapter 1

THE VILLAGE OF POLAND, TOWN OF RUSSIA AND HERKIMER COUNTY

The village of Poland, New York, had many names over the years but settled on its current one because, much like Europe, the village exists on the southwestern part of the town of Russia in Herkimer County. It's a beautiful area that's right near the edge of the Adirondack Mountains. Right down the road from the town of Newport, the area was a slice of wholesome Americana that was dotted with the farms and houses of those who worked in local factories. Back in 1914, the village of Poland had a population of about 350. The population was sparse but host to hardworking people who were used to rugged winters and beautiful summers. Utica, Syracuse and Albany are all less than a few hours from where the murder of Lida Beecher occurred, yet in the early twentieth century, the area had a small-town charm and residential closeness that exists to this day. In 1914, Poland would be populated by hardworking farmers, factory workers and merchants. Poland had been a dairy farm area since the 1700s, having been settled by New Englanders. William Buck came to Poland in 1827 and purchased a farm on Buck Hill, where the road would lead to the location of the murder of Lida Beecher. The first school started in 1795, and Susan B. Anthony visited on February 20, 1863, to lecture on emancipation. There would not be electricity in the village until 1918; at the time of the crime, gas street lamps illuminated the way. Poland had a train stop that made it a valuable and important place to conduct trade and commerce. At the time of the trial, the daily train to Herkimer would be full of Poland and town of Russia residents who were very fond of the Gianinis and supported the fight to place Jean in

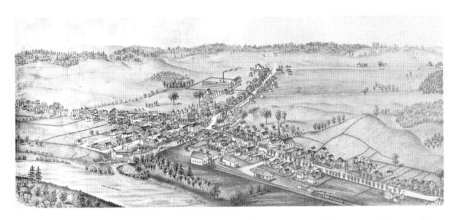

Poland was given its name because it is in the southwestern part of the town of Russia, like the geographical layout of the European countries. *Courtesy Herkimer County Historical Society.*

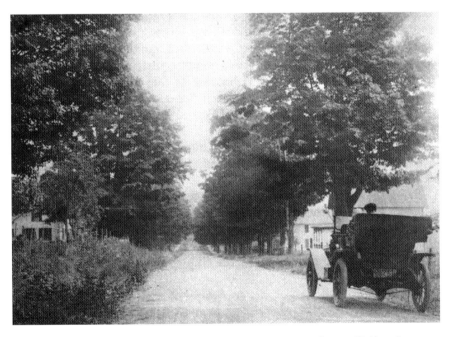

The simple beauty of early twentieth-century Poland, New York. *Courtesy Herkimer County Historical Society.*

The Shocking 1914 Case of a Vengeful Student

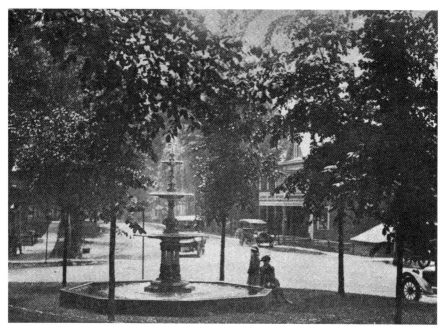

Poland would not have electricity until 1918. When Lida was murdered, the village still had gas street lamps, and lanterns were carried by citizens at night. *Courtesy Herkimer County Historical Society.*

an asylum rather than being sent to the electric chair. To this day, Poland is a charming place full of friendly people who cheerfully offer a smile and a wave. It's a wonderful and enchanting location that rarely exists anywhere else in our country.

Chapter 2

THE CRIME

The following are the facts of what happened on March 27, 1914, when Jean Gianini, sixteen, lured his former teacher, Miss Lydia "Lida" Beecher, twenty-one, up Buck Hill Road in the village of Poland, New York, under the pretense of showing her the new house his father was building. There wasn't anyone there when they arrived, and when Lida realized there was nothing up there, she decided to go back. This is when Jean took out a monkey wrench and cracked Lida across the back of her head. She slumped to the snow-covered ground and moaned. Upon examination of her body, it was concluded that more additional blows to the head were applied by the killer. Lida's glasses had flown off from the initial severe strike. After Jean hit her the additional times, he dropped the wrench and took out a butcher knife. He stabbed Lida multiple times until she was dead. Jean dropped the knife, grabbed her by her ankle and dragged her across the road and under a barbed-wire fence, over two hundred feet, to a thicket where he left her body. Jean picked up the butcher knife and fled the scene. He left behind the monkey wrench and a one-inch piece of cloth from his jacket. A button was later found on the ground that matched one missing from the same jacket, and blood was found on his sleeve. It's interesting to note that blood from a human and an animal could not be differentiated at that time. Gianini slept in his bed that night and attempted to run away the following morning. When Jean was caught and brought back by the law, a very odd interaction occurred. Jean was being led up the village street when Undertaker Sprague came by with the dead body of Lida in his cart, uncovered. The teacher had

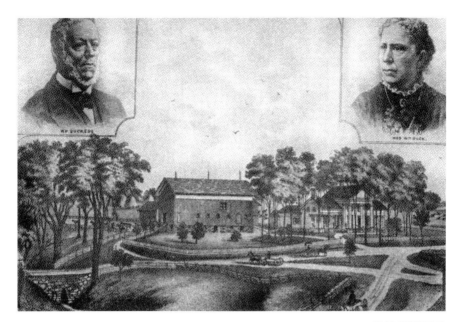

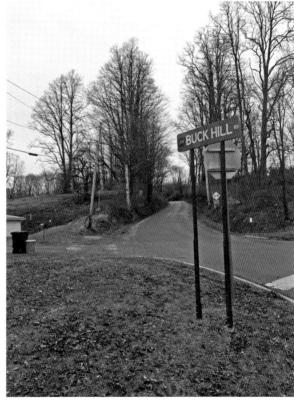

Above: William Buck established his farm on Buck Hill in 1827 in Poland. Jean led Lida up Buck Hill Road to commit his crime. *Courtesy Herkimer County Historical Society.*

Right: Lida was led up Buck Hill Road, where Jean confessed he had lured her to get his revenge. *Photo by Dennis Webster.*

The Shocking 1914 Case of a Vengeful Student

Jean striking down Lida. *Drawing by Andrew Buffington.*

sat in the rain for two hours after her discovery until the cart came to take her away.

Jean confessed his crime and was placed on trial for first-degree murder. A guilty verdict would send the sixteen-year-old Italian boy to the electric chair. This would lead to one of the most dramatic, groundbreaking and precedent-setting trials not only in Herkimer County but in the entire United States. A student had murdered his teacher, his confession would lead to cries of manipulation and his insanity defense would bring the

Jean Gianini's home in Poland, to where he fled after the murder. *Courtesy Town of Russia.*

The boardinghouse of Lida Beecher in Poland as it looked in 1914. *Courtesy Town of Russia.*

The Shocking 1914 Case of a Vengeful Student

The Poland schoolhouse where Jean was taught by Lida Beecher. *Courtesy Town of Russia.*

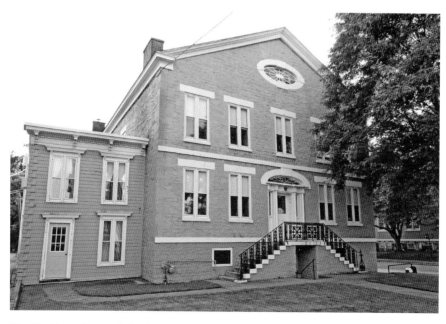

The Herkimer County Jail, which held Jean Gianini in the same cell that had held world-famous killer Chester Gillette. *Photo by Dennis Webster.*

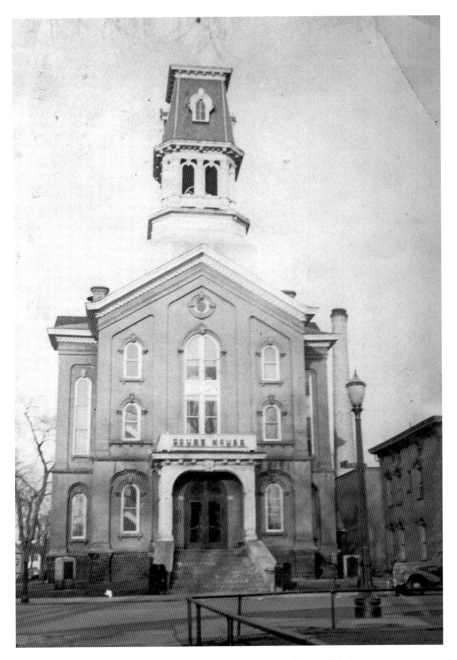

The Herkimer County Courthouse. *Courtesy Herkimer County Historical Society.*

The Shocking 1914 Case of a Vengeful Student

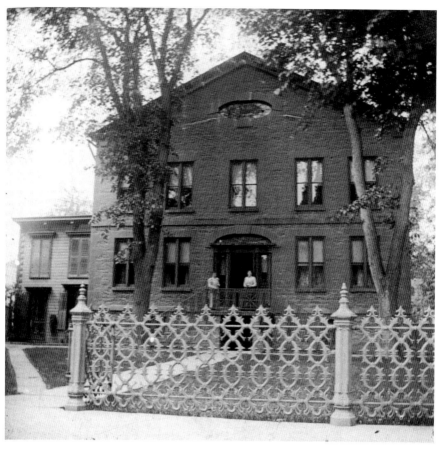

The Herkimer County Jail. *Courtesy Herkimer County Historical Society.*

world's best and most respected alienists (or psychiatrists) to the tiny village of Herkimer, New York, and its majestic courtroom. The battle of these medical experts would bring forth the controversial Binet Test and result in a verdict that stunned the country and led to criminal trials using insanity as a defense in a new direction.

The trial would garner national press and draw large crowds from the entire area, including a large contingency that would take the train down from Poland to the village of Herkimer. The leader on the bench was Judge Irving R. Devendorf. The defense would consist of counselor John F. McIntyre and counselor David C. Hirsch, both from New York City, and attorney Charles Hane. The prosecution would consist of District Attorney William E. Farrell and brilliant prosecuting attorney Charles Thomas. Alienists for

the prosecution would include Dr. Charles Wagner, Dr. Charles Pilgrim, Dr. Willis Ford and Dr. Palmer. The defense would have the most experienced, respected and seasoned alienists, including Dr. Frances Quinlan, Dr. Charles Weeks, Dr. Carlos MacDonald, Dr. A. Walter Suiter, Dr. Charles Bernstein and Dr. Henry Goddard. Dr. Goddard had seen and diagnosed over forty thousand imbeciles worldwide in his storied career. The court stenographer was Susan G. Sanborn, who was secretary to Judge Devendorf. The trial would prove to be groundbreaking and controversial. The crime Jean committed would be almost an afterthought to the drama and battle that would be played out in the Herkimer County Courthouse.

Chapter 3

MAJOR PLAYERS IN THE MURDER AND TRIAL

LYDIA "LIDA" BEECHER

She was only twenty-one years old when she followed her troubled student out of Poland, New York, and into the snows of winter to be murdered on Friday, March 27, 1914. Her death occurred under a slight mist of rain dripping on the remaining banks of snow in central New York. Lydia "Lida" Beecher was only trying to help a troubled student and paid for it with her life in the form of a wrench to the back of the head and multiple stab wounds applied by her student, who was a mere sixteen years old. Teachers are drawn to the life of instruction, and Lida was no different. She was the daughter of a preacher and had wanted to help all her students, including the troubled and misbehaving Jean Gianini. She had tried to get him into other schools, wrote to the school to help him and talked to Jean's father about his son's behavior.

The following is a letter that was printed in the *New York Times* a month after the crime. A copy was sent by Lida's father, the Reverend William Beecher, to show she had been trying to help her student. This letter goes to the heart of what a sweet and caring young woman Lida had been:

> Dear Sirs & Madams,
> I was very much impressed with the work done for and by the boys and girls of your republic when I was visiting with a group of Cortland Normal Girls three years ago. Have you room for another citizen, a boy of fifteen

Murder of a Herkimer County Teacher

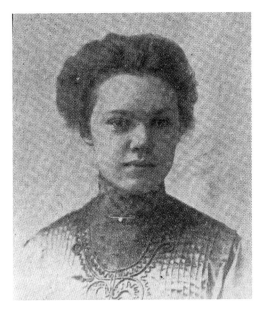

Left: Schoolteacher Lida Beecher was twenty-one at the time of her murder. *Courtesy Herkimer County Historical Society.*

Below: Lida with friends Cornelius Schermerhorn, Florence Schermerhorn and Ethel Plumb at the Poland reservoir in 1913. Lida is third from left, wearing a huge smile. *Courtesy Paula Johnson.*

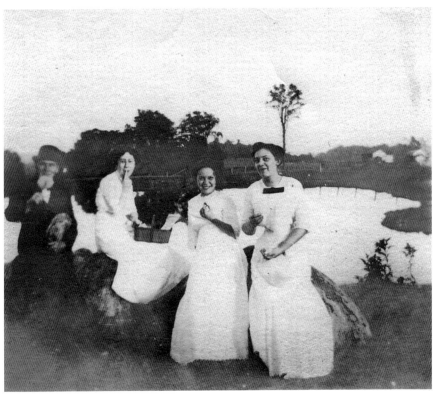

The Shocking 1914 Case of a Vengeful Student

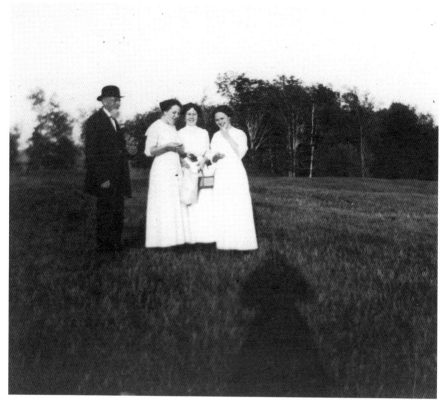

A smiling Lida (*far right*) would be murdered six months after this photo was taken. *Courtesy Paula Johnson.*

years? He is a good hearted boy, one of my pupils last year and one of my most interesting boys. His mother died when he was too young to remember and left his father with Jean, the boy, and an older sister to care for, in New York City. Jean's father married again. The boy's father finally thought it best to move up into the country here, but it, of course, seemed pretty dull for such city-bred children, and the girl returned to New York City.

The father thinks a lot of the boy and has tried to do what he could do for him. As I have said, Jean was one of my pupils last year. He dislikes school work. He got a working certificate with his father's consent and went to work in the mills four miles from here. He became restless. I don't know what the trouble was, but he drew $5 and started to go somewhere away from home. He went to Buffalo, New York, Philadelphia, Albany and Lyons, among other places, but he got no work. Finally he called upon some humane society. They found out who he was, and he was sent to the

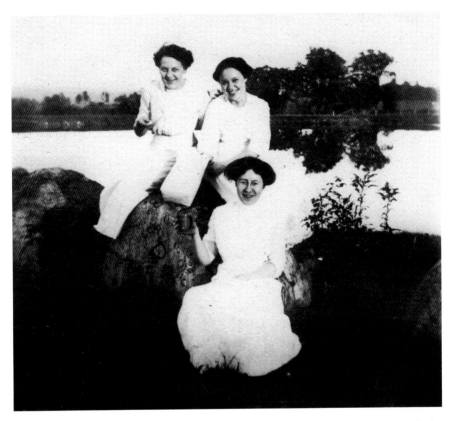

Lida (*first row*) was described as sweet, loving and fun by her friends in Poland. *Courtesy Paula Johnson.*

Catholic Reform School in Utica. On his return he did not like it here and had nothing in view. If he could get into some place like the George Junior Republic, where he received a little treatment as well as hard work, it would be fine for him. He responds to kindness very readily. He is not a bad boy by any means. He is simply unhappy at home, but is ambitious, and has other fine qualities that would develop if he only had a little guidance to show him that he really could amount to something if he chooses to.

I had a little talk with Jean to-night about the place. Jean seemed to be quite interested when I explained as well as I could what was expected of him. Would you please send circulars of your school, for I am pretty sure that Jean's father, who is well educated and wants to make something out of his only son, would be delighted.
—*LIDA L. BEECHER*

The Shocking 1914 Case of a Vengeful Student

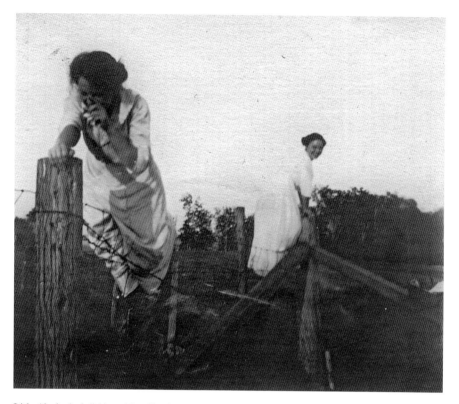

Lida *(far back, frolicking with a friend)* climbing on a fence near the Poland reservoir. *Courtesy Paula Johnson.*

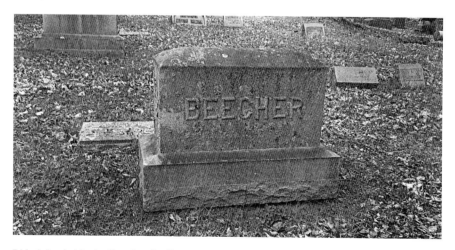

Lida is buried in the Beecher family plot in the Onondaga Valley Cemetery in Syracuse, New York. *Photo by Dennis Webster.*

Lida was described in the press as a "road angel" who gave her life assisting a student in need. She's remembered as young, beautiful and sweet in disposition. The letter printed here shows her dedication to her students, and her father said that Lida lost her life in a Christian purpose, helping a student. A sad after note was the fact that Lida was planning to leave Poland Central School District a few months later, as she had applied for a position at Onondaga Valley Academy to teach at her alma mater. She had wanted to be nearer to her parents. She came to Poland to teach after graduating from the Cortland Normal School.

Jean Gianini

The young man had been in trouble for years, even with other teachers at Poland Central School. He was born on December 5, 1897, in New York City and given the name Jean Martinette Gianini. He would be undersized, growing to a height of five feet, three inches and weighing less than 120 pounds. He was described as walking with a peculiar gait. His father was Charles A. Gianini, and his mother, Sarah "Sally" Cecelia McVey, was twenty years old when she married Charles. Before the marriage, Sally had been deemed a bright, vivacious, stylish person who was much accomplished in music. Not long after her marriage, she became sloppy in her appearance, depressed, morose and indifferent. The first child of the Gianinis was named Charles and was born severely disabled on November 13, 1891. He lived to seven years old and never could speak but would grunt sounds. Charlie was unable to walk and dragged himself across the floor on his hind quarters. He died at seven when he choked on a piece of food. Sally Gianini never recovered. She became odd and started to tell everyone she was a "Negress" and refused to go out in public as she was black. It was at this point that she became a raging alcoholic. Priests intervened to get her to break the habit, but she could not. Sally was melancholy, but she gave birth to Catherine "Moffie" Gianini on July 12, 1894. Catherine would be the only normal child she had, as Jean was born a few years later. Sally soon became hysterical and drank heavily and did unpredictable things. For example, she threw all of her husband's books out the window in a rainstorm. She became silent and would stare ahead and not talk or answer questions. This was what Jean was born into and raised in.

The Shocking 1914 Case of a Vengeful Student

Shortly after Jean's birth, Sally refused to breastfeed him, and he became malnourished. Sally was sent away to St. Anne's Sanitarium in New York City, and Jean had to be bottle fed and was handed over to a Mrs. Leigh, who cared for the boy until he was six years old. Sally died in the institution on June 3, 1899. Her death was attributed to meningitis and heart failure due to alcoholism. Jean was a late talker and was bounced from place to place until he landed at Lady Cliff Academy on the Hudson, where he appeared small and filthy. He finally stopped grunting and began to speak. When Jean was ten years old, he took two young girls into the woods and made them strip naked to play Indians. Soon after, Jean was observed eating mud pies, and the other children called him "loony."

During the next few years, Jean lived in the Bronx, and he would tease smaller children and once stole a wagon. He had a habit of taking girls' hats and throwing them over fences. He was still young when he came home with a bleeding gash on his right temple and said he got it falling off a wall while teasing a girl.

In 1910, the Gianinis moved to Poland, New York, into what had been called the Peterson Home. Jean left the Bronx for a sleepy upstate small town full of unsuspecting children. Jean attended Poland Central School until 1913, when he left to work at a knitting mill in Newport, New York, right down the road from Poland. At that time, he started his pattern of running away and hopping freight trains. He was found a few times in Ilion, New York, washing dishes at a hotel. His father would take him back to Poland, but Jean would run away again. He went to Albany, and when he came back, he bragged to everyone that he had been shot at a few times by the police while he was stealing. One time he was fishing with his family. He stood by the water and was getting bitten by black flies so badly that he had blood running down his face, arms and legs, yet he refused to leave until he caught a fish. When asked if the flies were bothering him, he said, "No."

Jean's behavior kept getting worse until his father sent him away to St. Vincent's School for Juvenile Delinquency. He was there for six months and had strict Christian Brother treatment. It didn't help him. He returned home worse than ever and was observed playing with toys and tag with children much younger than himself, which seemed very odd for a boy now sixteen years old. He chased his sister with a knife for no reason and threatened a young boy named Arthur Jones with the same knife with which he would eventually kill Lida. Jean's father caught the boy masturbating. Jean admitted he did it quite often, and his father started to sleep in the same room to watch him and stop him from the evil habit.

Jean was declared not guilty by reason of insanity and sent to Matteawan State Hospital for the Criminally Insane in Dutchess County, New York. *Courtesy Seth Voorhees.*

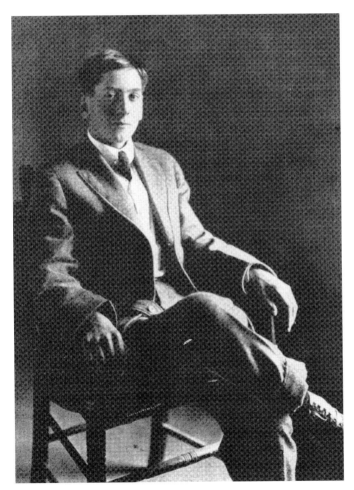

Jean's portrait as he awaited trial. Absent are his glasses, which had been discussed in the trial as part of the diagnosis of his mental condition. *Courtesy Herkimer County Historical Society.*

The Shocking 1914 Case of a Vengeful Student

Soon after, Jean lured Lida Beecher away and murdered her. After the trial, Jean was admitted to Matteawan State Hospital for the Criminally Insane in Dutchess County, New York, and lived a long life. He died at ninety years old. He was never free from the asylums.

His Confession

Jean's confession was subscribed and sworn in front of Fred Moore, justice of the peace of the town of Russia, on March 28, 1914. During the trial, it was revealed that the confession had been dictated and written down in pencil by Undersheriff John Nellis. Jean did not have his father or his attorney present when the confession was given. All officials had was Jean's signature on the written confession. Jean's defense attorneys tried to get the confession thrown out, as they claimed Jean was scared and confused at the time it was taken and that his constitutional rights had been violated; however, the confession was allowed to stand. The following is the exact transcript of the confession, signed as true and correct:

> *Jean Gianini, being duly sworn, deposes and says he resides in the village of Poland and is sixteen years old; deponent further says,*
>
> *"I went to school to Lida Beecher and had trouble with her and wanted to get revenge. I met her above the hotel and walked up the street with her up beyond the stone quarry; she had been a coming to see my folks about school and was a coming up to see them last night and I told her they lived up the hill, and when we got up there on the left side of the road, I hit her with a monkey wrench that I got out of my father's barn. I had the wrench in my pocket when I went up. After I had hit her about three times with the wrench, I hit her with a knife several times, to be sure to finish her, and then I took her over in the lot; dragged her by the foot; and then I went home and got there about 7:30. The knife I stabbed her with was one that belonged to my father and I took it home and put it in the pantry drawer. I left the wrench somewhere near where I had hit her. When I hit her first, she did not scream but moaned. She said she thought it was quite a ways and did not see any house. I was not afraid when I got home; I was just as happy as I ever was and didn't think anything about it as I thought I had revenge. I make this statement voluntarily and under no fear or threat and knowing the same may be used against me." Signed Jean Gianini.*

The interesting thing is there was a theory that Jean had an accomplice and might not have committed the crime himself but may have been present when it occured. It was widely known that Jean had tried to solicit friends to help him get revenge on Lida Beecher. Jean's father had their defense attorney, John F. McIntyre, try to investigate this theory, but Jean would not cooperate and would only say, "I'm not a snitch." Charles Gianini said Jean had only been out of the house for twenty minutes and that made it impossible for him to go up that hill, commit the murder and return home. Many felt that Jean's confession was done under duress and he really didn't know what he was saying or signing his name to; however, the confession was upheld.

Jean was arrested and placed on a train at the Poland station, with Sheriff Stitt and Sheriff Wilson seated next to the boy. They were surrounded by reporters inside the train who were throwing questions to Jean, who sat with his hat pulled down over his eyes, hugging himself. Jean would not answer and kept shaking his head no at the reporters. The train arrived at the station in Herkimer, and reporters wrote that half the village had turned out to see Jean escorted from the train to the jail. Random spectators were yelling out to "lynch the boy," "string him up" and "let me at him." Jean was reportedly frightened and shaking and clung to the police escorts. The crowd and yelling followed Jean all the way to the jail. Hundreds mulled around the street corners next to the jail and yelled out random threats to the boy. The angry mob eventually dispersed.

The puzzling part of the crime is Jean's motive to murder. He'd been out of the Poland classroom for almost a year, and the discipline he had received from Miss Beecher was nothing close to being something a person would fester over and move to murderous action. There had to be more. The trial would reveal the dark Gianini family secrets and Jean's mental state. It would make for one of the most dramatic and historic criminal trials in not only Herkimer County and New York State but the whole United States. He was described in the press as a "dullard" and a "degenerate" who was sluggish in his movements, but there was more to the young man than the newspaper-reading public realized.

Charles Gianini

Charles was the father of Jean and a prominent Poland citizen. He was from New York City and had a successful furniture business. He was a

well-respected businessman and liked by all who worked with him. He had relocated to Poland and soon became a valuable member of the community. His first wife gave birth to three children and then became an alcoholic who suffered from mental illness that would consume her and cost her life. Charles remarried and tried his best to keep his family together.

He was present for every minute of the trial until he testified. After testifying, he didn't show up every day and was said to have barely been there. Friends said he was embarrassed at the public airing of his family secrets, including the mental illness and alcoholism of his dead wife, his disabled son who died at age seven and the events of Jean's entire life. He spent his fortune on his son's defense. He aged greatly during the trial, as would any father who had to watch his son on trial for his life.

Sarah "Sally" (McVey) Gianini

Sally was the mother of Jean and first wife to Charles. Sally was described as a beautiful and accomplished young woman, but after the birth of her first son, she started to drink heavily and break down mentally. Her eldest child died at seven years old, and she was committed to an asylum shortly after her youngest, Jean, was born. Sally refused to hold the infant Jean or nurse him. She died in the asylum within a short time of being committed. During Jean's trial, her sad and tragic life would be put on public display for the entire world to witness.

Charles "Charlie" Gianini

Charlie was born and lived to seven years old but never gained the ability to walk or talk. He would get around by dragging his body across the floor and grunt as his only means of communication. He choked to death on food, ending his life abruptly. His illness was never diagnosed, but his affliction had a devastating effect on his mother.

Catherine "Moffie" Gianini

She was the middle child of Charles and Sally and sister to Jean. Moffie was dedicated and very close to her brother. She would stop and buy Jean fresh fruit every day, go to his cell to deliver the food and sit and talk to him while he ate it. She sat right behind Jean in the courtroom audience, with her father and the wives of the defense attorneys right next to her. In a grim statement, a reporter from the *Syracuse Herald* called Moffie's devotion to her brother during the trial "pathetic" and "sad." She was pointed out by alienists as proof that Sally Gianini could produce a normal child, as Moffie had no physical or mental deformities. The only time Moffie left Jean during the trial was when her father was testifying about the horrible condition of their mother. Moffie fled the courtroom in tears, and it was said the entire congregation wept at the testimony about the mental collapse of Sally Gianini.

Reverend Dr. William A. Beecher

The beloved preacher and father of Lida struggled in the days after the death of his daughter. Her death baffled him, and he stated to a reporter from the *Auburn Citizen*, "I can't understand anyone not liking Lida or wanting to harm her." He said with a hurting heart, "She loved everyone and she hated to hurt the feelings of even the poorest and humblest of creature. Her

Lida Beecher's home in Sennett, New York, where her Presbyterian faith was formulated by her preacher father. *Courtesy Herkimer County Historical Society.*

The Shocking 1914 Case of a Vengeful Student

whole life was one of service. Her greatest ambition was to be a missionary. She wanted to offer herself to the board last fall but I persuaded her not to. To wait a while. I was selfish. I guarded my little one to God." Reverend Beecher's lips quivered, and he had tears in his eyes as he continued, "To see her a happy wife some day with her children around her and I am punished. But, oh why should this have happened to her, my little girl." To show how much he was a man of faith, Reverend Beecher visited Jean in his jail cell, held his hands and told the lad he forgave him for his crime.

David C. Hirsch

Hirsch was one of the highly paid defense attorneys from New York City. His expertise was of great assistance in the case.

Charles Hane

Hane was the Herkimer defense attorney and first lawyer retained by Charles Gianini until Charles hired McIntyre and his partner, Hirsch. Hane would assist in the defense of Jean and was part of a team of amazing experts from Herkimer County.

David C. Hirsch, the brilliant defense attorney for Jean Gianini. *Courtesy Herkimer County Historical Society.*

John F. McIntyre

McIntyre was the lead defense attorney for the Gianinis from New York City. He was brilliant and expensive; Charles Gianini spent his life savings to bring the man upstate to save his son. McIntyre's press release stated:

> *We don't admit this lad was concerned in this crime. We protest he is mentally unsound, a trait inherited from his mother; that he was incapable mentally of premeditating the murder; that he could not have lured up*

Murder of a Herkimer County Teacher

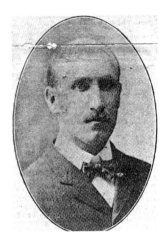

C.B. Hane assisted in the defense of Jean and opened the trial with his statement.
Courtesy Herkimer County Historical Society.

that country road the young woman who was so well acquainted with him as to know there could possibly be nothing to any representations he might make to hears [sic] to the success of an appeal with his father to get him back to school; and that the defense can see in the crime a probable reason to suppose her body was carried up the hill and dragged into the field by one or more who were physically capable of committing the murder in that way.

This statement, along with those of the alienists who came to Herkimer, forced the prosecution to prepare with alienists of its own.

Charles Thomas

Thomas was a brilliant and dynamic prosecuting attorney for Herkimer County. He fought brilliantly against defense attorney McIntyre and caused a huge protest when he took the weapons of the murder, the wrench and knife, and waved them in the air in front of the jury. He wore a white flower pinned to his suit jacket every day to show sympathy and support to Lida, but the heat of the courtroom made it wither by noontime. He had a very short time to put together a prosecuting strategy and battled against the best money could buy from New York City. His main opponent, defense attorney McIntyre, would go on to praise Thomas as one of the most brilliant attorneys he had ever met and gone against in a courtroom.

William Farrell

District Attorney Farrell led the prosecution but deferred most of the questioning during the trial to Charles Thomas. Farrell delivered the prosecution's closing statement to the jury.

The Shocking 1914 Case of a Vengeful Student

Judge Irving R. Devendorf

Judge Devendorf came from humble beginnings, as he was born on a farm in Danube, New York, in 1856. He graduated from Little Falls Academy in 1877 and went on to pass the New York State bar in 1880. He started out as the district attorney in Herkimer County and was elected a judge sometime later. It was said that he was a highly respected and honorable man. His first murder trial as a judge was the case concerning the murderer Chester Gillette, who would be found guilty and sentenced to die in the electric chair. Judge Devendorf was another example of the excellence in integrity and knowledge produced in Herkimer County, and his steady approach held the trial of Jean together.

Dr. A. Walter Suiter

He was a prominent Herkimer doctor who testified for the defense and called what Jean suffered from "progressive idiocy." Dr. Suiter battled against Herkimer County prosecutor Charles Thomas, their offices a mere stone's throw away from each other and across the street from the jail cell that held Jean Gianini. There is no doubt that Dr. Suiter's opinion mattered very much to the members of the jury, as he was one of their own from their county.

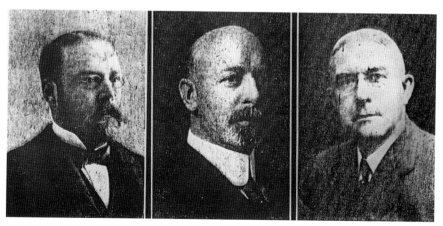

Alienists fought in dramatic courtroom fashion. *From left to right*: Dr. William Mabon, New York City; Dr. H.L. Palmer, Utica; and Dr. A. Walter Suiter, Herkimer. *Courtesy Town of Russia.*

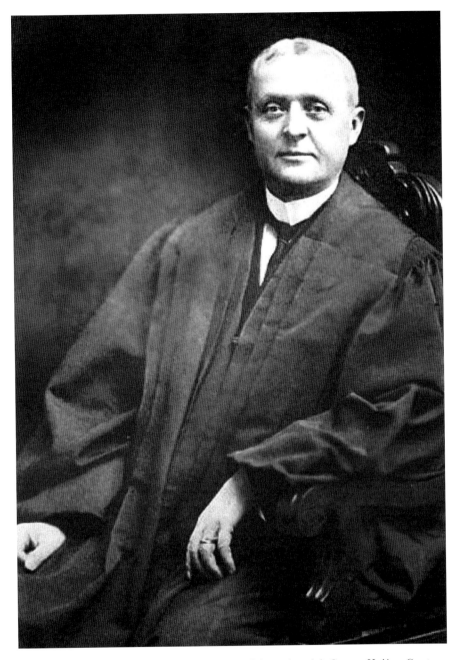

Judge Irving R. Devendorf oversaw the Jean Gianini murder trial. *Courtesy Herkimer County Historical Society.*

The Shocking 1914 Case of a Vengeful Student

Dr. Henry H. Goddard

Alienist Dr. Henry H. Goddard had seen over forty thousand feeble-minded patients in his career and used the Binet Test to classify Jean Gianini as a high-grade imbecile with the mentality of a ten-year-old. *Courtesy Herkimer County Historical Society.*

There was no alienist more experienced or highly regarded than Dr. Goddard. He brought the Binet Test for intelligence to the United States from Europe and used it in the trial of Jean Gianini. Dr. Goddard was instrumental in children with mental disabilities being allowed a school education and would study more imbeciles than any person before or since. At the time of the trial, he was the director of the Vineland Training School for Feeble-Minded Boys and Girls in Vineland, New Jersey. Dr. Goddard published many papers and journals on morons, feeble-mindedness and the application of the Binet Test to assign IQ and categories of people within these scores. His testimony, but especially the Binet Scale application to Jean, was the main factor in convincing the jury to place Jean in an asylum rather than the electric chair.

Dr. Carlos F. MacDonald

Dr. MacDonald was another notable alienist called by the defense. He would also apply the Binet Test to Jean and conclude that the boy was an imbecile. Dr. MacDonald was one of the designers of the electric chair, yet his testimony kept Jean from frying on his insidious invention. Dr. MacDonald supervised many institutions for people with mental disabilities and, for sixteen years, was the New York State commissioner in lunacy. He supervised many facilities for the insane, most notably the New York State Institute for the Criminally Insane in Auburn. He was present in 1890 when the first person was executed in the electric chair. Dr. MacDonald examined Leon Czolgosz, who assassinated President McKinley. He pronounced Czolgosz sane and was present when he was executed in the electric chair. Dr. MacDonald was a formidable presence and assisted greatly in Jean being found not guilty by reason of insanity.

Murder of a Herkimer County Teacher

Henry Fitch

The dairy farmer was the one who came upon the crime scene and found Lida Beecher's body. He found Lida's glasses on the ground near trampled and bloody snow. He followed the drag marks the tragic two hundred feet to where her body laid next to a bramble. Fitch was described as a very successful dairy farmer; however, he tragically committed suicide in December 1914, a mere nine months after discovering the murder victim. He shot himself through the heart with a shotgun. Fitch was described as being in the best of health and left behind many sons and daughters. He had lived and died on Buck Hill. That fateful snowy March day changed the man, with many saying he never got over the discovery of Lida.

Brainard Wilt

Jean's teenage acquaintance gave a written statement about Jean talking about murdering Lida. He was not called to the stand during the trial, but his signed statement was used in the case against Jean. Brainard signed an affidavit that stated Jean had solicited him to assist in the murder of Lida. This showed that Jean had premeditated the murder. Brainard's affidavit was written and signed:

> *I am employed by Eli Darling of Poland. I have known young Gianini for about one year and a half. When he came out of the St. Vincent's protectorate he told me how he got pinched. "Two weeks after I came out of the Woods," Jean began to tell me of his troubles. Monday night we were going down to the Edwin Hotel. Jean said to me in substance: "Miss Beecher is coming to my place to see my father about taking me back to school. She doesn't know where I live and I'll take her by and on up above. When I get her up there." Jean asked me to come along and help him. I told him I would not. About 7:30 o'clock Tuesday night Jean came into the barn while I was cleaning the horses. We talked about the horses first. Then he said that he wanted to break into the Union store and get the money there. He said he would skip out with the money. Then he asked me if I would go with him. I said no I don't want to get into it. Then he asked me if I had any tools for the job and I said no. After that he began to talk about the teacher and said that she did him dirt and sent him away from school. He*

The Shocking 1914 Case of a Vengeful Student

said he was going to kill her when he got a chance. I said I wouldn't work it that way. Then he said to me, "have you got a revolver or a gag?" And I told him no. He went away after that. I was not a particular friend of his. I guess he thought I was though.

—*Signed Brainard Wilt. Subscribed to me before me this 29th day of March 1914. Signed A.R. Brayton, notary public*

Ethyl Clark

Clark was from Rochester, New York, and had come to Poland to teach. She was a roommate of Lida's and her best friend. She was also engaged to, and would marry, Lida's brother, Willis Beecher. She tendered her resignation to the Poland Central School District immediately after the murder and left town. Willis was chief yeoman on the flagship *Tennessee* at the time of Lida's death. He returned home and married Ethyl within weeks of Lida's death. Ethyl accompanied Lida's body back to Sennett, New York.

Chapter 4

STENOGRAPHER'S TRANSCRIPT OF THE TRIAL

It's one thing to read a reporter's take on testimony that happened in a courtroom during a criminal proceeding; it's another to read the exact words from the mouths of those who testified under oath, in front of an all-male jury, the judge, prosecutors, defense, defendant and public audience. The Herkimer County Historical Society allowed unprecedented access to a file box full of the typed transcript, as done by the court stenographer. The case is listed as *The People of the State of New York v. Jean Gianini*, with the subtitle *Transcript from Stenographer's Minutes*. Judge Irving R. Devendorf would preside over the trial of the century in Herkimer County. The trial was conducted over many days from May 11 through May 28, 1914, with much detail condensed below. Leaping from these pages were the raw emotions of the families, one with a murdered daughter and one with a son facing death by electric chair. Reporters wrote that every day, at least six hundred people would crowd the street and rush to get a seat in the courtroom. This caused panic and screaming as spectators got pushed as a mad rush occurred, with people sprinting to get the seats up front in the courtroom. The doors were locked every day once every place a person could sit or stand had been taken. Outside, the front steps to the courthouse, the streets and the sidewalks would be packed with hundreds of spectators, many gawking at Jean as he would be led by a prison guard from the jail across the street to the courthouse. Jean would drop his head and look at the ground as they walked the human gauntlet. It was mentioned that a person with a movie camera was there filming the trial, and also, dozens of young ladies were dressed in

their finest and stood as Jean was led past in order to make a connection with the teenager. It was described as morbid curiosity blended with a teenage girl crush on the dark-haired lad. There's no doubt the trial was a spectacle that had never been seen before or since in Herkimer County.

The court transcripts are an incredible and amazing account of every single statement of the trial. The battle of the lawyers and alienists was something not seen in a courtroom before or since. There are many details within the large volumes that are new to the history books. The following statements are taken right from the volumes of pages. The almost four thousand pages have been condensed and presented here:

Volume I: The Prosecution Presents Its Case on May 11, 1914

Opening Statement by Charles Thomas

This was the afternoon session of May 11, 1914, and prosecuting attorney Charles Thomas was representing the Herkimer County district attorney's office. Thomas started by stating that the jury was present without bias and that Jean Gianini was being prosecuted for first-degree murder. He stated that the father, Charles Gianini, had moved his family to Poland, New York, into a home on Main Street. Jean was thirteen years old at the time of the move and attended Union Free School in Poland, with Miss Davis as his teacher. Miss Davis was an older, experienced teacher and stated that Jean was acceptable to her punishment and, when he misbehaved, accepted his whipping. In September 1912, Poland received a new teacher, Miss Lydia "Lida" Beecher, who was young and inexperienced and not capable of handling a troubled young student. As Jean misbehaved, Miss Beecher placed him in a special chair in the lower room. He continued to disobey, so she turned his chair so Jean was facing the wall and could not see any other students or his teacher.

Jean had grown tired of his schooling and applied for, and received, a laborer's certificate that allowed him a leave to work. He never had gainful employment and, from this time to the murder, bounced from job to job. It was shortly later, on March 15, 1914, that Jean encountered Lida outside where she was boarding at the home of J.D. Countryman on Main Street in

the village. Lida was walking with Miss Clark, another teacher at the school, when Jean walked with them to the post office and asked Miss Beecher to please speak with his father and get him back into school. (On a side note, Miss Clark would become Mrs. Beecher when she married Lida's brother.) Lida told Jean it was not advisable to come back to school, as there was only a short time left in the year, but she promised to speak to Jean's father about coming back the next semester.

A few weeks later, on March 27, Lida was seen by several witnesses walking with Jean on the same route from the post office. Three boys and three girls testified that Miss Beecher turned the corner with Jean, and that was the last anybody saw of her until her dead body was discovered. Charles Thomas then told the packed courtroom that he would prove Jean led Lida past the Gianini home and wanted to show her the new home his father had supposedly purchased out of town on Buck Hill Road. It was seven o'clock in the evening and getting dark when they arrived at the place of her murder. Lida innocently walked with Jean and then commented that she could not see any lights from the supposed new home. Jean tried to coax her to go farther, and when she refused and said she would speak to his father, Jean took out a monkey wrench with jaws and smashed her across the back of her head. Thomas went on to say Jean later told the authorities everything, including that when Lida fell to the ground and moaned, he smashed her in the head a second time. Jean said he then took out a knife and stabbed Lida in the back of her neck, into the side of her forehead and in other parts of her body. It was determined that Lida Beecher died of the severing of the pericephalic or carotid artery on the left side of her neck. Jean then grabbed Lida by the right leg and dragged her across the road, under a barbed wire fence and down a hill off the road, where he hid her body behind a bush. He paid no mind to her life's blood that seeped out into the white snow or the drag marks.

Jean ran home, where, upon entry, his father told him not to take his shoes off, as he had to run an errand. Charles Gianini asked his son to take a dollar and wallpaper sample books down to Thomas Owens. Jean complied and came home later, throwing the samples in the corner. He rushed off to catch a logging train and missed it, so he returned home and slept in his warm bed without a care in the world while Lida was dead in the cold night snow.

Before the murder, Jean had worked at Samuel Hutchingson's and would eat his meals at that establishment. After sleeping in his warm bed, Jean went to his employer in the morning and ate a full meal before he fled Poland. He went to the railroad tracks and fled for Newport, New York. A witness saw

him enter the station in Newport, look at the time and then leave back on the tracks toward Herkimer. It was on these tracks that a person caught up with Jean and escorted him to Autenrith's Market, where an officer took him into custody to bring him back to Poland.

Charles Thomas paused and then went into the discovery of Lida's dead body by a dairy man who had made early morning milk deliveries. Henry Fitch lived on Buck Hill Road and had his son with him when they noticed a red streak in the snow along their route. He stopped and discovered an umbrella, rope and the red streak continuing across the road and down a slight hill. Fitch followed the trail until he witnessed Lida dead next to alder bushes with her clothes in much disarray. She had on a raincoat over her regular clothes. Fitch went into Poland and sounded the alarm. Men came out to the site, where they discovered the dead teacher, the umbrella and the rope, along with her eyeglasses, her hat, false hair and a button that would end up being from Jean Gianini's coat. Lida's body was taken to Sprague's Undertaking, where an autopsy was conducted to identify the exact cause of her death. Her body was released to her father, Reverend Mr. Beecher, who took Lida back to their hometown of Sennett, New York.

According to the Thomas testimony, Jean returned to his father's home, where he confessed to killing Lida. He had the knife he called a "good blade" and said no blood was on it, as he had wiped it clean in the snow. When asked where the pipe wrench was, he said he had thrown it over the fence at the scene. Investigators returned to find it. Jean was placed under arrest and taken to the Herkimer Jail, where he possibly revealed his motive. He said that while his teacher, Miss Beecher had humiliated him. When Jean was away at St. Vincent's School for Juvenile Delinquency in Utica, New York, he planned his revenge. Thomas would state that Jean had remarked to male friends on numerous occasions that he was going to get revenge on Miss Beecher by ruin, rape, disfigurement or murder.

Jean had claimed not guilty by reason of insanity, and it was up to Thomas to use the evidence to convict. He would go on to say that just because Jean was "odd" it did not make him insane. He told the jury that they must not be fooled or swayed by the age or mentality of the murderer.

Ethyl E. Clark-Beecher Called to the Stand

Ethyl was a teacher at Poland Central School and a former roommate of Lida's. Thomas referred to Lula Beecher, and Ethyl corrected him by saying

The Shocking 1914 Case of a Vengeful Student

her name was Lida. She testified that she had met Jean Gianini a few days before Lida was murdered. She stated that Jean walked from the post office with them back to their boardinghouse and was discussing Miss Beecher talking to Jean's father to get him back in school. Ethyl described exactly what Lida was wearing when she saw her right before she left and was murdered: a red dress with a little bit of white frill around the neck and black buttons, her tan raincoat, a black-and-white checkered hat with a black velvet rim, her umbrella that had a brown wooden handle with the initials "LB" on it and her glasses. Thomas then showed Ethyl an umbrella and what he called "nose glasses," not spectacles, that Ethyl swore were Lida's. They were received as evidence. Ethyl testified that Lida had dark brown hair and wore it up, being held by brown-colored bone hair pins. Defense attorney John F. McIntyre did not protest the garments being added as evidence. Ethyl described Lida as short, under five feet tall and under one hundred pounds, with dark brown hair and brown eyes. She then testified that when they were with Jean he said he hated his home, hated his father and did not want to stay in Poland and be a sod buster. He said his father had whipped him for stealing apples, yet it was other adults who had put him up to the crime. Jean then asked about the industry reform school and then about Auburn and whether they hanged convicts or placed them in the electric chair. Ethyl said she thought the conversation odd, as Jean then talked about Sing Sing

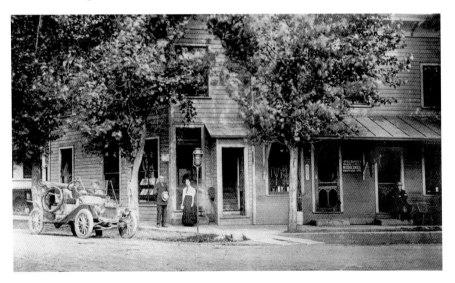

The post office in Poland where Jean talked with Lida just a few days before her death. *Courtesy Town of Russia.*

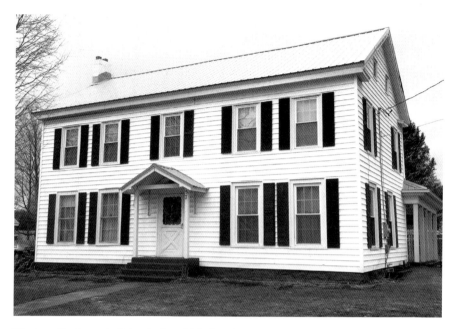

The boardinghouse in Poland where Lida Beecher lived at the time of her murder. *Photo by Dennis Webster.*

prison and the work the prisoners had to perform. On cross-examination by defense attorney McIntyre, Ethyl admitted that she and Lida had laughed at Jean when he spoke of being an actor and the prison discussion. She also said that Lida was being patient and kind to Jean as she offered him advice.

Gertrude Trask Called to the Stand

Gertrude was sixteen years old when she testified that she lived in Poland in the house across the street from the Gianinis. On March 27, 1914, she was going to the Poland Union Store with Margaret Dagenkolb and Grace Palmer. She purchased a can of salmon at the store. The girls were walking to the post office and met up with Lyle Danning and Claude Barhydt. Gertrude testified that she and the group were near the Hotel Carlton and saw Lida Beecher walk by, and Lida said "halloa" to the group. They then witnessed Jean Gianini join up with Miss Beecher and walk away past the Gianini home and out of their sight. She said that Lida and Jean were heading up toward Buck Hill. On cross-examination by the defense, Gertrude testified that before joining up with Lida, Jean had pulled down her hat and poked

The Shocking 1914 Case of a Vengeful Student

Inside the Poland Post Office. Lida left the boardinghouse of Mrs. A.D. Countryman to mail a letter and never returned. *Courtesy Herkimer County Historical Society.*

one of the girls in the back. She had previously mentioned Jean throwing snowballs but under oath could not recall him doing it. But she did say she did not see Jean with a knife, metallic tools or rope. There was a heated exchange between the prosecution and defense when Thomas asked if Jean had ever acted peculiar. Gertrude said she and Claude did testify it was foggy and darkening, but the streets were lit by kerosene lamps on street posts.

Charles Palmer Called to the Stand

He was the father of Grace Palmer, who had been harassed by Jean Gianini while walking with other teens. He was the son-in-law of John Countryman and was visiting him in Poland at the time of the murder. He did not see anything other than Jean and Lida walking together at 7:15 p.m. but under cross-examination could not recall if it was the young man in the courtroom.

Lyle Danning Called to the Stand

This fourteen-year-old was visiting from Herkimer. He was with all the other kids and testified to seeing Jean standing behind a tree, as others had recalled.

Lyle had known Jean when he previously lived in Poland and testified that when he saw him, Jean shook his hand and bragged that he'd been arrested five times since he'd seen him last and had been held by a humane society in Albany. Lyle testified that he last saw Jean walking away with Miss Beecher. He said Jean was his normal self that evening.

Henry Graves Called to the Stand

Henry had known Jean since he had moved to Poland and saw him at 8:10 p.m. on a full run. He knew the time because he had looked at a clock inside the barbershop before stepping outside.

Samuel Hutchinson Called to the Stand

Samuel was Jean's boss at the time of the crime and testified that Jean had taken supper the night of the murder around six o'clock. Jean did errands, drove horses and drew freight. Jean had only been working for Samuel for eight days. Jean left the night of the murder after eating, and Hutchinson did not see him until six o'clock the following morning. Jean ate very little that morning. He had been a solid employee and worked very hard at whatever task he was given. Samuel testified that after breakfast the morning after the murder, Jean went to the barn. Neither Samuel nor his wife saw him again. This was contrary to his steady nature of work in the past week.

William J. Smith Called to the Stand

At the time of his testimony, Smith had lived in Poland for twenty-one years and had worked for the Herkimer County Coal Company. He testified that he knew Jean Gianini and had seen him on March 28, the day after the murder, walking down the railroad tracks a little after seven o'clock in the morning. Jean saw him and called out, "Hallo, Smithy," and was in a considerable hurry. This eyewitness testimony was confirmed by Albert Taylor, who was there with Smith when Jean rapidly walked the tracks heading away from Poland.

The Shocking 1914 Case of a Vengeful Student

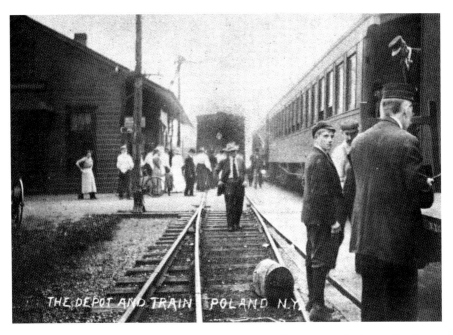

The Poland train depot. Jean Gianini had a fascination with trains and had aspired to be a railroad worker. *Courtesy Herkimer County Historical Society.*

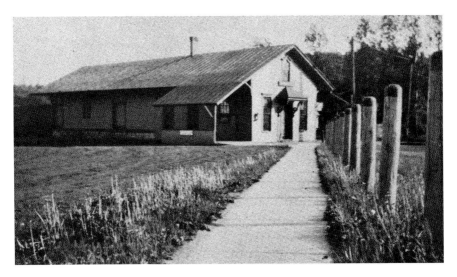

The Poland railroad station. Jean had been arrested for jumping trains. He frequently hopped trains to run away. *Courtesy Herkimer County Historical Society.*

James Countryman Called to the Stand

Lida had boarded with Countryman, and the man on the stand revealed the most horrific details of the crime, as he and a few others—Owen Lewis, Will Miller, Lawrence Lamb and a few more—had hiked out to Buck Hill Road and seen Lida's body. This was after Henry Fitch had come to town and told of finding the dead schoolteacher. The group of men found Lida's body by a thicket of alder bushes, facedown in the snow with her skirt hiked up past her waist, exposing her buttocks and legs. Her head was bloody, and she had messy hair. Countryman stated that he lifted up her legs and pulled down her skirt. He then got a horse blanket and covered her body. He was shown crime scene photographs and confirmed that was the place of the crime. He was instructed by the prosecution to speak louder, as the jury could not hear him. He was choking up on the stand in dramatic fashion. Then the prosecution took out a piece of rope that Countryman identified as the piece he had found at the scene of the crime. He had removed the rope and then gave it to the sheriff at a later date. It was described as thin rope, like a clothesline. He had also found a small button that did not match anything on Lida's clothing and handed that over to the sheriff. It was marked in the trial as evidence exhibit number 40. McIntyre and Thomas clashed over the evidence, with the judge ruling it acceptable. Interestingly, the blood of Lida's on the ground could not be called "human blood," for at the time scientists could not distinguish human from animal blood. Court was adjourned for the day, with the jury getting a lecture from Judge Devendorf not to discuss the case with anybody.

VOLUME II: THE TRIAL CONTINUES ON WEDNESDAY, MAY 13, AT 9:30 A.M. AT THE HERKIMER COUNTY COURTHOUSE

Henry Fitch Called to the Stand

Fitch lived in the town of Russia on Old State Road. He was fifty-eight years old and testified that he often traveled Buck Hill Road on his way to Poland. He was heading into Poland with his son Ernest to deliver milk to the milk station. He had been driving his sleigh down the snowy road pulled by a pair

THE SHOCKING 1914 CASE OF A VENGEFUL STUDENT

The spot under a thicket where Lida's body was found. Her seeping warm blood had melted the snow. *Courtesy Town of Russia.*

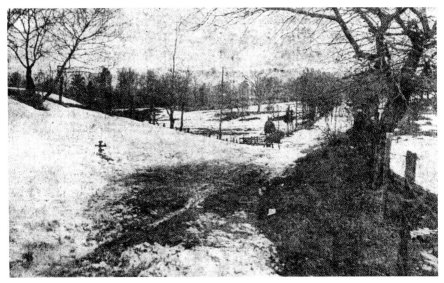

The scene of the murder on the left. Lida's body had been dragged by the ankle across the road and under the barbed wire fence to the right. *Courtesy Town of Russia.*

of horses. Fitch testified that as he drove down the road at 8:00 a.m., he saw an umbrella, a woman's hat and a hair comb broken in two. He saw blood near the items on the right-hand side of the road on snow about two feet thick. He saw a trail and footprints from the items through a barbed wire fence and past an apple tree. He followed the trail to the willow bushes and found the body of a young woman. She was facedown in snow, a little water and some black muck. Her clothes were pulled up, revealing her legs. Fitch then drove his sleigh into Poland and went to Mr. Sprague, the undertaker, and told him of the body. During the trial, Fitch was shown a photograph of the area where Lida was found and asked to mark with a red pencil where he saw the body.

Lawrence Lamb Takes the Stand

He was only thirteen years old when he was called to the stand, where he testified that he lived in Poland and had known Jean Gianini for two years. He knew Lida Beecher and stated that he was in the same class as Jean with her as the teacher. He had seen Jean a week before the murder at Samuel Hutchinson's, where he came upon Jean sawing wood on the side of the house. Jean had told him that he was going to put an end to Lida Beecher. Lawrence testified that in school, Miss Beecher had been kind and generous to Jean; however, Lawrence also said that Jean had been sent by Miss Beecher to the professor for throwing wads of paper in the classroom, making noises and tipping over his chair. Finally, Miss Beecher placed Jean in a chair away from the rest of the class facing a blank white wall.

Arthur E. Sprague, Undertaker and Furniture Dealer, Takes the Stand

Sprague testified that he had gone up to view the dead body of Lida Beecher on the morning of March 28 and had taken Harry Holcomb with him. They found Lida covered by a horse blanket, removed it and placed her body in a wooden coffin. He screwed the cover on and had help carrying it into his wagon. He took Lida down to his undertaker parlor. He conducted the autopsy the next day, on March 29. Sprague testified that it was Lida Beecher he had examined.

The Shocking 1914 Case of a Vengeful Student

Leo Coonradt Takes the Stand

He testified that he was friendly with Jean and talked to him many times. He told the packed courtroom that the night before the murder, at the train depot, Jean was saying that he was going to do something the people of Poland would be sorry for. James Brothers took the stand right after Coonradt and had also been at the train station, and Jean told him that he was not in school anymore because of Miss Beecher and that he was going to get even with her before spring.

Lawrence Larned Takes the Stand

This twenty-one-year-old worked with Jean at Thomas Rooney's Feed Store. He testified that Jean had worked with him before the murder and had taken his jacket off while they were loading bags of feed. He had to move Jean's coat, and it was heavy, so he looked in the pocket and it held a monkey wrench, much like the one used to bash in the head of Lida Beecher. It was twelve to fourteen inches in length and was missing the wooden handle. As everyone testified, there had been a back and forth between the prosecution and the defense, yet this testimony of the wrench in Jean's coat pocket caused a lengthy and heated debate among all the lawyers and the judge. The testimony was allowed to stand for the jury to consider.

Morris Howe Takes the Stand

The fifteen-year-old from Poland was walking down Main Street on March 26 when he stopped to talk to Jean Gianini. Jean had asked if Miss Beecher went to church by herself and retrieved her mail by herself. Morris said he did not know, and Jean replied that he'd get even with her. The prosecution asked why Morris didn't tell anybody of authority what Jean had said, and Morris said he didn't make much of it.

Estes Compo Takes the Stand

He worked at Samuel Hutchinson's place and was in the barn shoveling manure when Jean happened to come in to talk the day before the murder.

Jean stated that he hated Miss Beecher, as she had tried to send him away to school. Compo testified that Jean, with a large grin on his face, said that if he had a revolver, he would kill her. Compo paid no mind, as he thought Jean was kidding around because he was smiling while making the statement. Jean then talked about how a colored man had killed a woman downstate and had blamed a manager in a nearby factory and that manager was sentenced to the electric chair. Compo stated that in his room at the boardinghouse, he had a revolver and a large knife hanging on the wall of his room. Jean had been there previously to visit him and fixated on the weapons, stating that his father had a knife of the same size and shape. Compo had told Jean not to touch the revolver, as it was loaded. Compo ate breakfast with Jean the morning after the murder, before Lida's body was discovered. Compo testified that Jean was his normal self at the table and was not agitated or different in any way. An interesting note the prosecutor mentioned was that Jean had bragged to many people that when he lived in New York City, he had been a lion tamer.

Charles Bockus Takes the Stand

He was a clerk at the New York Central Station and said Jean popped in the morning after the murder, looked at the clock and mentioned he was going to Newport to get meat for his father at Autenrith's Market. He testified that Jean then slowly walked out the door and down the railroad tracks toward Middleville.

Henry Gaffey Takes the Stand

His entire testimony was in regard to the size and weight of the wrench that was used in the crime. He was the official sealer of weights and measures for Herkimer County. The wrench was listed as evidence exhibit number 45, and Gaffey testified that it weighed two pounds, seven ounces and fifteen-sixteenths of an ounce. It was weighed on scales provided by New York State. It was twelve inches in length, and the head was five and a half inches from tip to back. The width was seven-thirty-seconds of an inch. He testified that the wooden handle was missing and that it was rusty and the jaws could not open.

George Sweet Takes the Stand

He had seen Jean the day after the murder in Newport when he was leaving Autenrith's Market. He had witnessed Jean walking at a swift pace. Sweet testified that he caught up with Jean and asked him where he was going, and Jean said to Herkimer to see a motion picture show. Sweet told Jean that his father was looking for him and he was to come with him back to Poland. Jean tried to run away, but Sweet grabbed him by the collar of his jacket. Jean started to strike at Sweet, who shrugged it off and yanked Jean by the collar. Jean then tried to say that a lawyer in Newport named Charles Fellows was going to sign papers to send him away. Then Jean said he had stolen a dollar from his father and he became frightened. Sweet then bought Jean a bag of peanuts that the teenager ate, only stopping to smoke a cigarette. Sweet said to Jean that they had found a dead body in a field and asked if Jean knew about it. Jean said he knew her as a teacher.

Dr. Fred J. Douglas Takes the Stand

The doctor from Utica testified about his coming to Poland to the undertaker's office to perform the autopsy on Lida Beecher. The doctor gave the details. Lida was a healthy white woman of 126 pounds. Her hair was full of clotted blood with some dirt. Blood had smeared across her face, and a puncture wound was on her face. There were stab wounds on her left and right temples, both a half inch in length. There were five lacerations on her scalp. There was a wound on the back of her neck by her spine. On the right side of her neck was another puncture wound that pierced the trapezius muscle. She had two abrasions on the right side of her cheek. On Lida's right shoulder were a couple more puncture wounds. She had abrasions on her right hand. Dr. Douglas opened her skull, examined her brain and declared it to be normal and undamaged. He found a lot of blood pooled around Lida's spinal cord. She had a cut on her left ring finger. Dr. Douglas testified in a packed courtroom that he then opened an incision from her breast bone down to her pubic area. Her heart and lungs were normal. The stomach contained a little digested food, and her liver was normal. He took her uterus out, placed it in a jar and gave it to coroner Huyck. The doctor determined she had died from a severed neck artery. She had bled to death.

Frank Newman Takes the Stand

This was the testimony that covered Jean's confession to the crime. Newman had driven to Newport looking for Jean, as Lida's body had been found and Jean was under suspicion. Jean got into the horse and wagon with Newman and confessed to Lida's murder on the way back to Poland. Newman mentioned to Jean that they were looking for him for the murder of Lida Beecher, and Newman testified that Jean replied, "They can't give me but ten years, can they?" Newman then replied with, "They are liable to give you the chair," referring to the electric chair. As they were arriving in Poland, they witnessed the rig carrying Lida's body, and Jean stated, "They are coming off the hill with her now." Jean then hunched up and didn't speak anymore. Newman testified that he said to Jean, "Well, you now have more than running away staring you in the face." Newman brought the wagon into the Gianini family barn, where they were met by Jean's father. Newman testified that within a half hour Sheriff Stitt and Undersheriff Nellis arrived. Newman had chased down Jean multiple times in the past when the lad had run away from home.

After a long day, the trial adjourned until the next day.

VOLUME III: THE TRIAL RESUMES ON THURSDAY, MAY 14, AT 9:30 A.M.

Deputy Undersheriff John Nellis Takes the Stand

The undersheriff testified that he had known Jean for a couple years. He spoke to Jean when he had him in custody and was at Justice Fred Moore's house. The sheriff left Jean with him, and he had Jean take all of his clothes off to examine him for any cuts or abrasions. He then turned the boy over to Sheriff Wilson and Sheriff Stitt. He had asked Jean a couple questions, but Jean didn't talk. Jean's father was in another room, sitting and waiting. Jean did not have an attorney present. Jean's father had brought attorney Hane, but he was not present when Sheriff Nellis questioned him. Nellis testified he had read Jean his rights and then went

into questioning Jean about the murder. The district attorney arrived, and Jean signed his dictated statement in view of everyone there: the coroner, Charles Gianini and the law officers. The justice of the peace took Jean's signed statement. The signed statement was then brought out in the courtroom. Jean did tell Sheriff Nellis he had lured Lida up the hill to exact his revenge. Jean said that he had gone home after the murder and slept better than he ever had. Nellis had gone to the Gianini home and retrieved the knife and testified that he found the wrench in the exact spot where Jean stated he had discarded it. He testified that Jean had asked, "Gillette got the chair, didn't he?" and then followed it up with, "He had no reasons to kill the girl but I did. I wanted revenge."

The next series in the courtroom dealt with the wrench, the knife, Jean's coat and Jean's signed confession being accepted as evidence. Defense attorney McIntyre strongly fought to keep the signed confession from being accepted, as he stated that Jean was frightened and all alone when the confession was written and signed. He had done it without his father or attorney present. Nellis testified that Jean was cold and calculated when he had confessed, and only the lump in his throat rising and falling gave any indication he was nervous. Interestingly, the testimony showed that Jean had great knowledge of the Chester Gillette case and the man being fried in the electric chair. Jean kept referring to that case and outcome when he spoke to authorities. The undersheriff went on to say that Jean talked with a cool demeanor about insanity being his reason for killing, but he told Nellis he was as sane as him. Jean started talking insanity after he had signed the confession and spoken to his father and attorney Hane. Things got graphic when testimony showed they had asked Jean if he had ravished Miss Beecher and attempted violence against her virtue. Jean said the thought had never entered his mind and he did not do any such thing.

Justice of the Peace Fred H. Moore Called to the Stand

Moore held the office of justice of the peace in the town of Russia and used the front part of his home to conduct judicial business. He testified that he had read Jean the confession, and the lad said "yes" to it and signed it in his presence. Justice Moore said he was not present when the undersheriff had Jean strip off all his clothes so the garments and his body could be inspected by law enforcement. The defense considered this a horrific thing

to do to a scared teenager who had neither his father nor attorney with him. Jean's father and lawyer had been denied access to the boy, yet the sheriff, undersheriff, district attorney, Coroner Huyek and Coroner McGillicuddy were in the room.

Sheriff Deputy Sylvester Wilson Takes the Stand

The deputy testified that he was in the justice of the peace's house, sitting in the front room with Jean and his father. He overheard Charles Gianini ask his son if he told the truth. Jean responded, "Yes, father, I told the truth like you asked me." Wilson then told Jean that the people he was talking to could end up being witnesses against him in trial. Wilson testified that he said, "Jean, I can't understand how you got that young lady up the hill." And Jean replied, "That's easy. I told her my father lived up over the hill." The sheriff then asked, "Didn't she stop and hesitate?" and Jean replied, "Yes, she did, but then I hit her with the wrench." Jean then went on to say he ran home fast afterward and fell two or three times as he ran. He got home and read the newspaper as if nothing had happened. The heated testimony came when Sheriff Wilson testified that on Sunday morning at the Herkimer County Jail, he said good morning to Jean, who said, "Good morning, Mr. Wilson." The sheriff deputy then asked if he had slept well, and he testified that Jean responded, "I slept all right. I killed the girl and it's all over with." The defense objected, as there were no witnesses to the exchange, and the judge overruled. The sheriff then testified that he said to Jean, "You should plead not guilty." Jean then replied, "That would be a lie. I killed the girl." The sheriff replied, "Be a good boy, mind the turnkey and they will be good friends to you." The last thing Wilson testified was that Jean's eyes did not appear shifty or his demeanor changed.

Herkimer County Sheriff William H. Stitt Takes the Stand

Stitt testified that he had gone to Poland on March 28 and talked to Jean around 11:30 a.m. The sheriff talked to Jean that day only in the presence of Jean's father, and Charles Gianini had said, "Jean, you have lied to me. Tell the truth." He saw Jean the next day, up on the third floor where he was being held at the Herkimer County Jail. Jean then told the sheriff the entire detail of what had happened and confessed to killing Lida Beecher.

The sheriff testified that Charles Gianini visited his son at the jail on Monday, March 30, and asked Jean right in front of the sheriff if he had killed the girl. Jean looked at the floor and nodded twice. Charles Gianini responded, "God help you."

Court adjourned for the day

Volume IV: The Trial Continues on Friday, May 15, at 9:30 a.m. at the Herkimer County Courthouse

Herkimer County Sheriff William H. Stitt Recalled to the Stand

He testified that the knife used in the crime was given to him by Undersheriff John Nellis. Sheriff Stitt had shown the knife to Jean, who then admitted it was the one he had used to stab Lida Beecher. Stitt had also taken possession of Jean's jacket that the lad admitted he wore the night of the murder. It was missing a button on the right sleeve. The button that had been found near Lida's dead body was a match. It was revealed that Jean had called his father a "tightwad" and a "miser."

The Defense Starts Its Case

The prosecution, led by Charles Thomas, concluded, so now the defense, led by attorneys McIntyre and Hane, opened its case for the defendant, Jean Gianini. McIntyre asked the judge to throw out the charges of first-degree and second-degree murder, which was denied. Hane approached the jury and spoke with passion as he said the details of the crime were gruesome and the death of the beautiful Christian woman Lida was a great misfortune, yet Jean and the Gianini family had the greatest tragedy of all and the family secrets would be revealed in the trial. Jean's ancestry would be presented as the cause and effect. Hane talked of the father, Charles Gianini, being a man in the furniture business in New York City and having served his country in the National Guard Fifth Militia. Jean's grandfather, Charles's father, had served the Union in the

Civil War in the Fifty-Fifth New York State Regiment. He contracted fever when fighting in the Southern states.

According to Hane, Charles Gianini met and married Sally McVey, who was described as a beautiful girl, on December 31, 1890. While pregnant with her first child, Charles, Sally was diagnosed with stuporous melancholia. She became a raging alcoholic. She rejected Jean's older brother, and the infant was raised by nurses. Charles was described by Hane as a "feeble, frail being" whom they "hardly thought…would live." He was described as grunting and never speaking or walking up until he died from choking at seven years old. The next born was Jean's older sister, Catherine, who was normal, but her birth pushed Sally deeper into depression, and Charles Gianini had to hire nurses to care for her. Sally's drinking caused her confusion, and she would stop coming home and her husband would find her passed out drunk in the back of stores or wandering the streets intoxicated beyond reason. When Sally gave birth to Jean, she went deeper into depression and insanity. She ran the city streets claiming she was black. She fell heavier into drink and psychosis. She began throwing books out the window. Sally was placed in the St. Vincent's Home on East Nineteenth Street in New York City, and within weeks she died of alcoholic meningitis. Jean was bounced around with caretakers until Charles remarried, and they brought Jean back into their home, but the father saw the lad was acting like his dead mother. It was revealed that Jean did not walk until he was three or four and didn't speak until he was seven years old. Then Jean began misbehaving in school in the Bronx, including making young girls undress. The father moved his family to Poland to get Jean a fresh start.

Hane then said the defense would call to the stand experts who would prove Jean was sixteen yet had the mentality of a ten-year-old and was an imbecile. Hane took a pause and then addressed the men of the jury, saying that imbeciles need to be taken from society and placed in institutions to care for them. Consequently, Jean should be incarcerated in a place that cares for imbeciles and never be allowed to roam the streets again. He said the mother drinking alcohol while pregnant made Jean what he was, and the jurors should not blame the lad for the sins of his mother. He told the jury, "Please, gentlemen, you are citizens and you are jurors. Take up the evidence and prove what I said here."

THE SHOCKING 1914 CASE OF A VENGEFUL STUDENT

Charles Gianini Takes the Stand

The father of the accused was forty-six years old at the time of the trial. He confirmed the date of birth and the attending physician of each of his children: Dr. Frances Quinlan at Charlie's birth, Dr. Jewett at Catherine's and Dr. Charles Weeks at Jean's. He testified that his firstborn, Charlie, never spoke until he died at age seven and would only grunt. Charlie never walked and only slid on the floor on his hind quarters. Charles testified that Catherine was normal at birth, but Jean was puny and weak. Jean had been rejected by his mother, so a nurse was hired to care for the boy. Charles rarely saw his son, as he lived with the nurse, and when he did see him he would yell very loudly until he acquired speech, which came about much later than other children. He called his nurse "Ma Ma." By the time Jean spoke and went home with his father, his mother was dead. Jean was then taken to Lady Cliff Academy, on the Hudson River at Highland Falls, which generally only took in girls but on occasion would take young boys. He stayed there for a year.

Charles said Jean lied quite a bit as a youngster and exaggerated. It was sad for Charles to describe Jean being made to eat mud pies by bullies when he was only ten years old. The father came upon this incident and found Jean on his hands and knees eating mud, with the dirt smudged all over his face, while the gathered crowd of kids chanted, "Loony, loony, loony!" and told Jean to "eat another one." Jean would take balls, caps, hoops and other items from children and throw them. One time, when Jean was ten years old, Charles came home and caught Jean chasing his sister through the house with a knife in his hand after Catherine corrected him on his behavior.

Charles moved his family to Poland to get a fresh start. His second wife, Florence Peterson, was from that area, and the family fell in love with the Herkimer County landscape. He testified that coming to Poland had started Jean's pattern of running away and misbehavior. Charles testified about the time Jean was fishing and was bitten by many black flies and had blood running down his legs, arms, face and neck. He didn't react at all and kept on fishing. Also, at sixteen, Jean was playing with children's toys, including blocks.

At this point, the defense asked the judge to have all the women removed from the courtroom, as the upcoming testimony was not appropriate for ladies' ears. The judge agreed, and all the women were removed. Charles described his dead wife, Sally, as being attractive, well dressed and sociable but said that it all changed once she became

pregnant. She turned dull and slouchy. She started to say she wanted to die but then also said she would live forever. Charles confirmed that his wife was telling everyone she was black after giving birth. She was under this delusion for months. He testified that she no longer loved him and started to go out all night and drink alcohol. Charles had made his money in the furniture business and struggled to run his business with a wife who was melancholy, drunk and missing much of the time. He'd find her asleep and drunk in his furniture store. She went on to die in an asylum shortly after the birth of Jean.

When asked about Jean's masturbation, Charles admitted his son did it nonstop and he would sleep in his son's room to keep him from doing the evil habit. He admitted under oath that he had physically struck Jean when the boy had been tormenting his sister. Jean was fifteen years old and Charles slapped him, and Jean wailed and screamed in response.

Dr. Frances J. Quinlan Takes the Stand

Dr. Quinlan was the physician of Sally Gianini before she was married and when she gave birth to her first child at twenty-three years old. He testified that during her first pregnancy, she didn't eat or sleep and her personal grooming habits went bad; the doctor called her "slovenly." She would sit on his doorstep all night, and when the doctor awoke, she'd be there asking him to make everything better. She told the doctor she was "awfully depressed." She had asked that the pain be taken away. When she did speak, it was prayers chanted repeatedly. She became haggard and would not wash, comb her hair or bathe. The doctor noted that Sally was peculiar and erratic even before her marriage. Dr. Quinlan testified that once Sally gave birth to Charlie, she ignored and shunned the baby. She was indifferent and inattentive to her child. She then went into what we now call postpartum depression, but the doctor deemed it melancholia. Sally would not get out of bed, talk or eat. She was in a coma-like state. The doctor referred to it as a "manifestation of hysteria in the brain." Dr. Quinlan testified that he examined Sally's urine and it was normal, yet he didn't examine any other excretions from her body. The doctor testified that years after the birth, Sally Gianini would barely speak and had a vacant stare.

The Shocking 1914 Case of a Vengeful Student

Dr. Charles L. Weeks Takes the Stand

Dr. Weeks had been a doctor at Bellevue Hospital Medical College and had treated Sally Gianini when she was giving birth to Jean. He testified that during her pregnancy, she was morose, depressed and melancholy but also unpredictable and wild. She would go long periods without talking and then talk nonstop for an hour. She'd be coma-like and then get hysterical. Dr. Weeks delivered Jean and described him as a small, poorly nourished, emaciated baby. Sally showed no emotion at all toward her son. The doctor testified that he used cathartics and bromide to quiet Sally during the birth and during the pregnancy had given her diuretics for her kidney ailment.

Court adjourned for the day.

Volume V: The Trial Continues on Monday, May 18, at 9:30 a.m. at the Herkimer County Courthouse

Charles Gianini Called Back to the Stand

He testified on the types of punishment he dealt to Jean for misbehaving, including extra arithmetic homework, spelling and whipping the boy with his hand and a horse whip. He testified that he had used the clothesline pole and a piece of clothesline rope to beat Jean. Charles testified that he had beaten and whipped Jean in the backyard and the barn, and one time the boy was in bed making noises so he went into his room, yanked him out of bed onto the floor and took Jean's head in his hands and pounded it over and over on the floor. Jean would holler and scream before Charles would touch him. The defense asked, and he answered, that Jean started wearing glasses at ten years old when he was taken to an oculist. He testified that Jean was disturbed, and he thought he was irrational for eating mud pies, making girls take off their clothes, chasing his sister with a knife and all the other incidences of misbehavior. The most difficult part was that when Charles would ask Jean why he was doing these things, the boy would only smile and not answer. He testified that Jean stopped going to Poland Central School in March 1913, a year before killing Miss Beecher. Jean bounced from job to

job as he struggled to maintain employment. Jean started to jump trains and had landed in Albany, where he got in trouble, including being shot at by a police officer. For some reason, the defense made a large issue of when Jean started to wear long pants. Charles testified that Jean began wearing long pants at sixteen. Charles said that the knife in evidence had come from his home but not the monkey wrench. He asked Jean if had killed Miss Beecher and his son told him no, but days later in the Herkimer County Jail, he looked his father in the eye and said that yes, he had committed the crime.

Alienist Dr. Carlos MacDonald Takes the Stand

Dr. MacDonald testified that he fought in the Sixteenth Ohio Cavalry of the Potomac Army. He worked at the State Commission of Lunacy. He personally visited every asylum and witnessed every patient in the state—three thousand total—twice a year. He had been a professor emeritus of mental disease and medical jurisprudence at the NYU Belleview Hospital for the last twenty years and the last four at the Albany Medical College. He had been the medical superintendent at King's County Lunatic Asylum, Long Island Hospital for the Insane, Binghamton Hospital for the Insane and the New York State Hospital for Insane Criminals in Auburn. His qualifications were impeccable, as he had written many journal articles, consulted at medical schools and testified in many cases dealing with the mentally ill, including the assassination trial of President William McKinley, who was shot by Leon Czolgosz. The assassin had his mental condition reviewed by Dr. MacDonald and was found sane and guilty; he was executed in the electric chair. There was no explanation why, but the assassin then had acid poured over his body as he was placed in his casket. The doctor had extensive experience with mentally defective children, having worked at Randall's Island for Atypical Children.

Dr. MacDonald had visited Jean in the Herkimer County Jail and evaluated the young man. He had Dr. Suiter from Herkimer with him at the assessment. He asked Jean basic questions about his birth, age and where he lived. The doctor did a physical exam and said Jean's head was misshapen and small. Jean stated that buying hats to fit his small head was difficult. Jean's tongue was straight and covered with a white substance. Jean's body was lopsided, and he was bowlegged. Dr. MacDonald looked over Jean's head and body for scars and then made the boy walk with his eyes closed and perform basic motor functions. Jean had a deformed palate inside his mouth

that Dr. MacDonald testified was common in those with mental defects, idiots and imbeciles. Jean revealed to the doctor that he had started smoking corn silk cigarettes at a young age in New York City and now smoked as many tobacco cigarettes a day as he could get. The doctor discussed Jean's bowel movements, and the lad said he didn't eat well and his movements were not regular. The doctor quizzed Jean about his self-abuse, or masturbation. Jean said he had not "self-abused" himself while in jail, a period of three weeks. He told the doctors he had learned to masturbate from another boy when he was thirteen and was still a virgin. Jean told the doctor that he was not bathing and had not washed his hands in many days, plus he was not sleeping well. Dr. MacDonald testified that Dr. Suiter had taken out coins and quizzed Jean on his math skills. He asked him how many dimes are in two dollars. Jean had answered correctly.

The court then took into evidence the notes Dr. Suiter and Dr. MacDonald recorded during Jean's exam in the jail. Jean revealed he frequently ran away, as he would be yelled at by his father and stepmother. He mentioned being cracked across the hands eighteen times when he was in reform school for misbehaving. Even though Jean was Roman Catholic, he rarely went to church, but he did tell the doctors he would see Father White in Poland and confess his sins of drinking, smoking, swearing and fighting. Jean told the doctors his father kept threatening to send him to a "bug house," which was a lunatic asylum.

When Dr. MacDonald asked Jean if he had killed Lida Beecher, the boy confessed with a stenographer and his attorney present. When Jean told the doctors he killed Lida with a wrench and knife, he smiled and laughed. He said he was not sorry and was only sad he was being punished for the crime. Dr. Suiter asked Jean if he were found guilty, would he rather be killed in the electric chair or get life in prison. Jean smiled and said, "Life in prison."

Jean was reading books in prison and especially enjoyed *The Red Man's Revenge* by Ballantyne. Jean said his dream work was to be a brakeman on the railroad. Jean told the doctors he was feeble-minded but not an idiot or lunatic. He didn't need to be in a straitjacket. He said sometimes he stared at blank walls for hours with no thoughts. Jean said he was sane but wasn't as smart as other kids his age. He did say kids in Poland had nicknames for him like Woppy because he was Italian. The kids in New York City would chant, "Jean, Jean, the sunburnt bean." That had angered Jean.

Dr. MacDonald then testified that Jean had many signs of being an imbecile due to stigmata, or signs. The left side of his face was a different size than the right, his ears were misshapen and not matching, his head was asymmetrical

and he had a long forehead—all signs of mental weakness. The doctor then testified that he had applied the Binet Test to Jean when he asked him to repeat verbally and in writing phrases the doctor put forth. The test helps determine the mental age of the child taking the test, ignoring the chronological age. Jean struggled at the simplest tasks and phrases. There was simple math as well that he could not perform. Prosecuting attorney Thomas objected to the use and results of the Binet Test but was overruled, as the doctor had performed the test many times. Dr. MacDonald ruled that Jean was indeed an imbecile with the mental capability of a ten-year-old. He defined imbecility as a mental defect in the brain that stunts development and growth.

Court adjourned for the day.

Volume VI: The Trial Continues on Tuesday, May 19, at 9:30 a.m. at the Herkimer County Courthouse

Dr. MacDonald, Alienist, Retakes the Stand

Prosecutor Charles Thomas questioned the doctor on his diagnosing Jean as a high-grade imbecile. The doctor stated that Jean was indeed a high-grade imbecile, which is a mental defect. He testified it was a defect and not a disease. Thomas tried to get the doctor to say that Jean knew what he was doing at the time of the murder and was sane in doing it. The doctor kept refusing to give an affirmation that Jean knew it was wrong to kill Lida Beecher. Thomas stated, "Now, doctor, in a purely alienistic way, inherited tendency is denominated predisposition, isn't it primarily?" The doctor agreed yet still wouldn't agree with Jean's motives. Thomas grilled Dr. MacDonald valiantly and intelligently on Jean's motives and actions in the murder but couldn't get Dr. MacDonald to agree that Jean showed premeditation by sharpening the knife before the crime. He did get the doctor to admit that Jean knew what he did was wrong, although he claimed that Jean didn't understand the complete ramifications. The doctor did state that a moron was a subdivision of an imbecile that was lower functioning and that Jean was not a moron. He testified that Jean, as a high-grade imbecile, could be prone to delusions and that these could

affect his abilities and judgments and lead him to act with a homicidal impulse. The courtroom was on edge as Dr. MacDonald used his alienist stellar reputation to state that Jean, in his imbecile mind, was justified in his killing of Miss Beecher. In other words, Jean didn't have guilt because his mental illness gave him the feeling that what he had done was just and right based on Miss Beecher disciplining him. Jean had the ability to plan and reason; it's just that these were delved from a flawed mind.

Anthony Miner Takes the Stand

Miner was a laundryman at St. Vincent's School for Juvenile Delinquency, where Jean stayed and worked for him. He said that Jean had asked him to help get him out of the reform school, as he wanted to go and set fire to his father's building for placing him in the facility. Out of the two hundred boys at St. Vincent's, only two worked in the laundry, and Jean had proven to be a hard worker and good listener. Miner said that he was no different than any other boy in the reform school.

Arthur Jones Takes the Stand

Arthur was only twelve years old when put on the stand and testified that in the summer of 1910, he spent several weeks with Jean at a country inn his family ran, where the Gianinis were staying as boarders. He said he and Jean hung around and fished together, but Jean frightened him one day by saying he was going to go upstairs, get his father's hunting knife and stab him to death. His mother, May Jones, took the stand right after her son and confirmed the altercation yet couldn't recall the reason for the boys arguing.

Alienist Dr. Henry H. Goddard Takes the Stand

Dr. Goddard testified of his college and medical experience, including eighteen years in the field of studying the problem of the mind. He had seen up to forty thousand patients who were feeble-minded, including individuals in other countries. At the time of the trial, he was working at the Training School for Feebleminded Children in Vineland, New Jersey. He was also a lecturer on feeble-minded children at NYU. He testified that most cases

of imbecility are present at birth, with some coming on later for various reasons. He testified that Jean had arrested development. His mind had been developing at a regular rate and then stopped. Sometimes a disease or injury can be the cause. Dr. Goddard had tested Jean on May 17, 1914, at the Herkimer County Jail with Dr. Suiter and Dr. Bernstein present. He examined Jean's memory, power of attention, reasoning abilities and other mental judgments. He used the Binet Test, which he said was a group of questions that are asked. These questions have standardized answers that are used to determine the mental age of the person under examination. Jean could only repeat up to six things but halted at seven. Dr. Goddard took out pictures and asked Jean to describe each one, which he did easily. He then showed him a picture of a square, took it away and asked him to draw what he had seen. Jean did this easily until he was shown a more complex drawing, at which point he struggled to redraw it. The doctor explained that the older the child, the tougher the test. Young children would get questions such as "What is the difference between wood and glass?" and "Count backward from twenty." He testified that the Binet Test questions and answers were different for each age, and that's how they can determine the mental age of an imbecile being tested. The Binet Test was being used in at least half of the mental institutions in the United States. Dr. Goddard testified that some states were using it in public schools, but not New York State. The doctor said Jean was jittery and easily distracted. He'd start talking to others while Dr. Goddard was asking him a question. Dr. Goddard and all those in the courtroom were read Code 1021 of the Penal Law, which is in regard to crimes committed by those with mental illnesses:

> *Offence committed by an idiot or lunatic. An act done by a person who is an idiot, imbecile, lunatic, or insane, is not a crime. A person cannot be tried, sentenced to any punishment or punished for a crime while he is in the state of idiocy, imbecility, lunacy, or insanity, or is incapable of understanding the proceeding or making his defense. A person is not excused from criminal liability as an idiot, imbecile, lunatic, or insane person except upon proof that at the time of the committing of the alleged criminal act he was laboring under such a defect of reason as not to know the nature and quality of the act he was doing or know the nature of the act was wrong.*

It was at this point that Dr. Goddard was asked if Jean was an imbecile, and he agreed that the young man was indeed under that affliction. The doctor was then asked the definition of stigmata. He stated that these are the physical

traits that accompany a feeble mind—the inequality of the ears and eyes, the condition of the tongue, the palate. He was asked if feeble-minded people have criminal propensities, and he said yes, with that trait appearing in boys around ten years of age. The difference between the feeble-minded and normal-minded is the feeble criminal doesn't understand when to stop. Dr. Goddard testified that imbeciles are like any regular person and will masturbate, grow attachments to people, etc. The doctor told the defense and the courtroom that Jean was an imbecile and unable to plan the crime in advance.

Court adjourned for the day.

Volume VII: The Trial Continues on Wednesday, May 20, at 9:30 a.m. at the Herkimer County Courthouse

Dr. Goddard Called Back to the Stand

The majority of Dr. Goddard's second day of testimony was spent being grilled by prosecutor Thomas on the validity of the Binet Test and the doctor's opinion of what the results meant. Thomas called the test ridiculous and said it was performed like a circus. The judge disagreed and dismissed the comment. Thomas asked the doctor to describe what cretinism is; he stated it was caused by the absence of a gland in the throat and that it led to imbecility that can be started off when development is arrested and that it can never return. According to Dr. Goddard, Jean would have the mentality of a ten-year-old for the rest of his life.

Angelica Putnam Takes the Stand

She had known Sally Gianini and had lived next door to her in New York City. She testified to seeing Sally drunk on many occasions and being led by her daughter, Moffie, who was pleading with her mother to go home. She had observed the eldest son, Charlie, and said all he could say at seven years old was "Da Da" and that he got around locomotive style on his hind quarters. She testified that Jean came into her home, where there was a party

being held for his sister. Jean was five years old and, for no reason, knocked over all the chairs and pulled the tablecloth, sending all the silverware and tableware flying.

Felicity Betigny Takes the Stand

Felicity lived in New York City and was Jean's aunt and sister of his mother. She testified that her sister had been a sweet, educated, beautiful girl who was a fantastic musician and singer. Her sister Sally became pregnant and lost all her vivaciousness. Her looks and demeanor faded, and she would not speak to anybody for an entire week. Felicity was sad as she recalled that her sister was so anxious that she had sucked two teeth right out of her mouth. She testified that right after Sally gave birth to Charlie, she took him out of the house in the middle of the night and placed him in a shed in the backyard. The nurse found the missing child. Felicity described Charlie as unable to speak or walk and having a very large head on top of a small, frail body. Sally rejected the child and formed no bond with him. Sally was convinced she was black and ordered that all mirrors be removed from the Gianini home so she could not see her reflection. Before the birth of Charlie, Felicity testified that her sister had never consumed alcohol, but post-birth, she became an alcoholic. She testified that her sister denied she was pregnant with Jean. When Jean was born, Sally said, "Oh my, he looked like one of the famine children of India. There was nothing to Jean. He was a perfect skeleton with a huge head and ears—awful ears." Sally rejected Jean and refused to feed the baby, even when he cried.

Alfred Y. Goodman Takes the Stand

Alfred testified that he had worked for Charles Gianini in his furniture store in New York City. He met Jean when he was eight years old and described him as a small, emaciated and poor-looking boy with shifty eyes. He stated that Jean had nervous and jerky movements that he referred to as "St. Vitus dance." His limbs would also twitch. Jean worked near him at the furniture store, and Goodman testified that Jean could not carry a conversation, answer questions or remember much of anything. One time, his father brought him oranges. Jean took the sack and ran off, and they found him ravenously eating them.

Mary Stanley Takes the Stand

Mary testified that when Jean was eleven years old, he was playing Indians with the other children and was chasing after them with an axe. She came running out of the house and took the axe away from Jean.

Jacob B. Auternrith Takes the Stand

Jacob ran a meat market and grocery store in Newport, New York. He testified that Jean had come in the morning Lida's body was found and that he did not seem distressed. Jean's father called looking for the boy, so they held him there until Frank Newman came for him. Newman worked for Charles Gianini and had chased after Jean many times. The gathered men had asked Jean if he knew Miss Beecher and if he knew about her death. Jean answered yes.

William Coon Takes the Stand

Coon testified to having caught Jean running around with a bag of salt, trying to dump it on the tails of his doves to keep them from flying. He had found the entire affair rather odd.

Poland Central School Principal Burt Robinson Takes the Stand

Principal Robinson was in charge of the school when Lida Beecher worked there and Jean was a student. He had set the chair in the place in the classroom where Jean had been segregated from the class. He referred to the spot as the "chimney corner." Jean was placed facing the wall because of misbehavior. Principal Robinson testified that he told Jean it was not a punishment but he had to stay there until he could do better. The idea to place the chair in that spot and put Jean in it was Principal Robinson's. Lida had told Principal Robinson that she didn't agree with Jean being placed in the chair in that position and felt it better that Jean be taken upstairs to sit in another room. Robinson testified that the only punishment Miss Beecher dealt Jean was making him stay after class. The small amount of corporal punishment was delivered by him and not Miss Beecher. Even though Jean was sixteen, he

was in the sixth grade curriculum and had been doing fair. He testified that Jean and his father came to him and asked for a work release and to sign working papers so Jean could leave school and go to work. A year later, he saw Jean and his sister, Moffie, walking in Poland, and Jean was upset and called his sister a "god damn whore."

Court adjourned for the day.

Volume VIII: The Trial Continues on Thursday, May 21, at 9:30 a.m. at the Herkimer County Courthouse

Burt Robinson Retakes the Stand

The principal at Poland Central School had brought Jean and his classmates' report cards to the courthouse, and they were admitted as evidence. Jean's grades had included a one hundred in history, a ninety-nine in grammar and at least a ninety in all of the other subjects. He stated that the students in Jean's class were two to four years younger than him. There had been twenty students in Jean's grade and in the classroom. He testified that Jean was moved because of his constant talking, whispering to classmates and being a complete distraction to the other students and Miss Beecher. He admitted that his "small amount" of corporal punishment was hitting Jean with a rubber tube on multiple occasions. He also told Jean not to hold a grudge against Miss Beecher. Robinson testified that Jean's previous teacher, Miss Lula Davis, had been more experienced than Miss Beecher and able to control Jean. He described Lida Beecher as a kindhearted, mild-mannered and loveable person.

Lula Davis Takes the Stand

She was the teacher of Jean Gianini before Miss Beecher. She had taught him in the fourth and fifth grades. She testified that he talked nonstop in class and even over other students when they were answering questions. She described Jean's walking as an odd shuffle with long strides and said that he would be bent

over and never stood up straight. Davis then testified that Jean would always look unkempt in school, with messy hair. One time, she said, he was absorbed in geography at his desk and was jumping up and down uncontrollably. She said that he had done this before and she threatened to whip him with a ruler. He told her that he was horse whipped at home and it would do no good, so instead she grabbed him by the collar and shook him severely until he said he had enough. He never again misbehaved in her class.

Peter Back Takes the Stand

Back was deaf, so the attorneys had to look directly at him and shout their questions. When he was answering, he was asked to talk louder. He owned and ran a harness-making business in Poland. Jean had gone into the store and asked for "strap oil" as a joke, so Back took a leather strap and smacked Jean in the legs with it until Jean hollered, "Stop!" He asked two more times, and Back whipped him two more times and said to Jean that he better realize someone was using him as a joke. Jean smiled and walked out of the store. On other occasions, Jean would come into the store, take tools and use them. Back testified that he'd take them away and yell at Jean. Another time, Jean took tacks and was nailing them into the wooden work table for no reason. He'd continue to come in the store and take the rope and tie knots. Back would tell Jean to behave himself and let him hang out. Back said he had liked Jean and didn't mind him hanging around the store.

Anna Newman Takes the Stand

Jean's stepmother was Newman's niece. She testified that she had known Jean for years, and over that time, the boy had worked on her and her husband's farm. She said Jean would often appear restless. He'd jump around and chase her children, and when he wouldn't stop, she'd whip him with a strap. She said his table manners were bad; he didn't know how to properly use a fork and knife, and then he'd wolf down his food as fast as he could. After he came back from St. Vincent's, and a few weeks before committing murder, Jean did some work at her farm and ate breakfast. He would not stop stuffing pancakes into his mouth, and she had to stop him after devouring sixteen. On another occasion, she had caught Jean teaching her boys how to masturbate in a wood shed next to her farmhouse.

Horace Newman Takes the Stand

Jean's stepmother was Newman's niece, and he testified that he had known Jean for six years. He said that Jean had visited him when he got out of St. Vincent's School. Jean asked Horace if his father really liked him. He testified that Jean wore glasses but would always have his cap pulled down over his face when he walked about town.

Fred E. Peterson Takes the Stand

Peterson was the brother of Jean's stepmother. He ran a farm and once asked Jean to gather the cows, but Jean had a hard time and said he was trying to get the cows to jump over the fence. One time, Jean slept over and Fred woke up to a noise and found Jean trying to sleep on the roof of the house. On other occasions he'd find Jean asleep hidden under a pile of clothes and once under a mattress.

Dr. A. Walter Suiter Takes the Stand

Dr. Walter was a prominent physician whose office in Herkimer is now home to the Herkimer County Historical Society museum. At the time of the trial, Dr. Suiter had been practicing medicine in Herkimer for forty-two years. He had worked for New York State in assisting physicians to being being certified to practice. Dr. Suiter had examined the mental health of over seven thousand physicians. He had a lifetime of treating people in Herkimer County who had mental illness and was used in many court cases as an expert on mental health ailments. His office building was right across from the Herkimer County Jail; he could see it from the window of his office. He examined Jean by himself, then with Dr. MacDonald and then with Jean's attorneys. His final exam of Jean was done along with Dr. Henry Goddard of the Vinland Training School and Dr. Charles Bernstein, superintendent of the Rome Custodial Asylum. Dr. Suiter had seen Jean longer than any other expert witness. When Dr. Suiter went alone to see Jean, he testified that the young man was happy, smiling and laughing while smoking a cigarette. He said the food in jail was decent. Dr. Suiter asked Jean to describe the crime and felt Jean's answers came across with what the doctor described as a "perfect indifference." On some answers,

The Shocking 1914 Case of a Vengeful Student

Dr. Suiter's office in Herkimer. The courthouse is to the right, and the jail is right across the street. Dr. Suiter would determine Jean Gianini an imbecile with a mental age of ten years. *Photo by Dennis Webster.*

Jean had a big smile on his face. Based on the interviews, Dr. Suiter testified that Jean was a high-grade imbecile. He felt that Jean was a grade below a normal mind and not an idiot. Dr. Suiter felt that Jean did not understand that murdering Miss Beecher was wrong. He felt that Jean suffered from ego, which resulted in Jean boasting of what he had done. Dr. Suiter used the term "melancholia insanity" to refer to Jean's mother. He said that it had to do with the reasoning power of the mind and depression and was accompanied by delusions. Dr. Suiter testified that Jean had the mental age of a ten-year-old—the same age determined by Dr. MacDonald and Dr. Goddard. He felt that Sally's excessive drinking had led to Jean being born defective. Jean had experienced arrested development because of his mother's actions that went back to his conception.

Court adjourned until the evening.

Volume IX: The Trial Continues on Thursday, May 21, at 7:30 p.m. at the Herkimer County Courthouse

Dr. A. Walter Suiter Recalled to the Stand

The defense attorney asked Dr. Suiter to explain what protoplasm is and how alcohol can affect it as it develops into a baby. Prosecutor Thomas objected and was overruled. Dr. Suiter stated that alcohol could result in a protoplasm becoming a high-grade imbecile. He testified that physical traits can give it away, such as vision problems and body deformities like a misshapen skull, a misshapen palate, long fingers and limbs that are longer than each other—in other words, a lack of body symmetry. Dr. Suiter had Jean remove all his clothes so he could examine his bodily proportions. He did this in the presence of David Hirsch, Esq., counsel for the Gianinis. He measured Jean's vitals, height and weight. He discovered that Jean's ears did not match and his hearing was different in each one. He noted a Darwin's tubercle on Jean's ears, and one arm was inches shorter than the other. Dr. Suiter testified that Jean made it almost impossible to complete the physical exam as he danced about the room, joking and shifting the entire time. "Jean treated the exam like a joke," said Dr. Suiter. The doctor gave an interesting answer when Thomas asked whether Jean were guilty or not guilty of murder. Dr. Suiter stated, "Neither. He's an imbecile."

Court adjourned for the evening.

Volume X: The Trial Continues on Friday, May 22, at 9:30 a.m. at the Herkimer County Courthouse

Dr. A. Walter Suiter Recalled to the Stand

Defense attorney McIntyre asked Dr. Suiter about meningitis alcoholism and Jean's result of the condition. He then went into Jean not knowing the murder was wrong. The doctor agreed that Jean did not premeditate the act

of murder and stated that his condition was the reason. Jean was under the delusion that he was being persecuted by Miss Beecher and thought that this persecution continued even after Jean had left school and culminated when he could not get back into Poland Central School. Lida Beecher was a "snitch," as stated by Jean. According to Dr. Suiter, delusions were part of Jean's high-grade imbecility. In his delusional mind, he was justified in murdering Miss Beecher and had no remorse for the deadly deed. This showed in Jean's escape from the crime scene not in the normal fashion of a murderer fleeing his crime. Dr. Suiter testified that Jean was an imbecile, which meant that he could be cruel to relatives and animals and lack empathy for anybody or anything. Then, Dr. Suiter was asked if an imbecile could recite and remember the Ten Commandments, especially "thou shall not kill." The doctor testified that just because Jean could remember the Ten Commandments doesn't mean he understood them. A high-grade imbecile would not know any of these commandments. Prosecutor Thomas asked if Helen Keller was an imbecile since she could not see or hear. Dr. Suiter said no. She lacked power of perception from her lack of sight and hearing, but that doesn't mean mentally she was an imbecile or even a savant. She had normal intelligence. Dr. Suiter again stated that Jean had a mental age of ten years old. He stated that of the five human senses, Jean had good use of four, with his vision impaired and wearing glasses. But he explained to the packed courtroom that Jean's affliction was of the mind and that some ten-year-olds can know the difference between right and wrong. Dr. Suiter testified that imbecility is a condition and not a disease.

Dr. Charles Bernstein, Alienist, Takes the Stand

Dr. Bernstein was working at the Rome State Custodial Asylum for the Feeble Minded, a New York State facility in Rome that had 1,370 patients. The doctor had twenty years' experience working with feeble-minded children when he took the stand. He also taught at Syracuse University Medical Department on feeble minds and eugenics. He was the doctor who reviewed all feeble-minded children to decide whether they should be admitted to the facility. He testified that he'd examined 5,000 such patients. Dr. Bernstein was a member of the American Association of the Feeble Minded and had visited every institution for imbecility in the United States. Charles Thomas asked the doctor to describe the three grades of imbecility, and the doctor replied, "You have the idiot, the imbecile and the moron class, all of which

is broken down into three grades." He testified that idiots have a mental age below the age of three, imbeciles are three to seven years of age and morons are eight to twelve years of age. Dr. Bernstein had visited Jean at the Herkimer County Jail and had examined him. He testified to the packed courtroom that Jean, in his professional medical opinion, was an imbecile. He believed that Jean didn't know what he was doing when he killed Lida.

Dr. Bernstein was there and observed Dr. Goddard applying the Binet Test. He found Jean's reaction to the ringing of church bells and how he paced waiting for his food odd. Jean stopped the examination so he could eat his soup. Dr. Bernstein testified that Jean had stigmata of degeneracy that was apparent in physical deformities. He observed that Jean had a small head, but the Darwin's tubercles in Jean's ears were the telltale sign. He said, "Jean's ears are indicative of the human race, a retroversion from an ancestral type, the remains of the ass or the monkey's ear, or tendency toward it." Jean's walk was described as a "shambling gait."

Dr. Bernstein then went on to describe the grades of imbecility: low, medium and high. A hydrocephalic imbecile has water on the brain, the microcephalic imbecile has a small head and the macrocephalic imbecile has a large head, but the degrees of intelligence can vary in all three cases. Jean fit into the microcephalic category and had unmoral characteristics that left him with a lack of moral responsibility. The defense then tried to get the court to allow photographs of the types of imbeciles to be shown to the jury but was denied.

Dr. Bernstein described that childish behavior like Jean had exhibited was a sign of imbecility. Jean tended to smile and grin all the time, no matter how dire or grim the topic they had discussed in the jail. The doctor stated that imbeciles suffer from delusions. Jean would have been under this state, being an imbecile, and would not know that his persecution by Miss Beecher was not real. Jean was delusional and insane. Dr. Bernstein agreed with the other doctors that Jean had the mentality of a ten-year-old. He testified that non-disabled people are called "normals" and that normals would deny murder; however, Jean was a high-grade imbecile and readily admitted to the murder yet felt justified in killing Lida Beecher, as his delusion made him feel it was the right thing to do. "Defective judgment" is what Dr. Bernstein called it. The doctor described strange behavior by Jean where the boy would yell out and neigh like a horse when he was about to be horse whipped by his father. Dr. Bernstein said that this behavior was an animal instinct. The judge interrupted and said enough of this kind of testimony and to remember who was watching in the courtroom. Then Jean's impulsive behavior was pointed

out, as the lad chewed gum and bounced his legs the entire trial as if he could not control himself. The doctor agreed that restlessness was part of the imbecility affliction and said that imbeciles must be in perpetual motion the entire time they are awake. The prosecutor asked if the doctor had seen Jean smiling and winking when the gruesome details of Lida's murder were being described. The doctor agreed it was crude of Jean to laugh, smirk, wink and show glee as the stabbing was being described yet stated that confirmed Jean's condition of being an imbecile and insane. Dr. Bernstein said Jean could not feign or fake his imbecility and absolutely should be placed in a mental health facility. The doctor was asked if an imbecile like Jean would grunt when lifting weights of over one hundred pounds, as Jean had worked in a warehouse lifting eighty-pound sacks of plaster. Dr. Bernstein testified that Jean's grunting or not grunting had nothing to do with being an imbecile.

District Attorney William E. Farrell Takes the Stand

Farrell was the district attorney for Herkimer County and was asked if he were present when Dr. Palmer of Utica and Dr. Mabon of New York City came to the Herkimer County Courthouse to examine Jean in April or May. Farrell had requested the examination. The district attorney said that he was not present at the examination. The two doctors were asked to testify but were not present. This caused the judge to adjourn until Monday.

Court adjourned for the day.

Volume XI: The Trial Continues on Monday, May 25, at 9:00 a.m. at the Herkimer County Courthouse

Lula Davis Recalled to the Stand

She had taught Jean for years before Lida Beecher and was now being asked about geography assignments that Jean had worked on and how competent a student he had been. She said that Jean had been a fair student. She did state that she had seen Jean in a fistfight during recess with Harold, a

classmate. She came upon the fight, let the two boys duke it out and let it go. She testified that she had cared for the boy, and when she had him stay after school one day, he was worried he'd get horse whipped when he got home. Jean confided in Miss Davis that nobody loved him. She testified that she had told Jean she cared for him. She said Jean did not appear right sometimes.

Lawrence Larned Recalled to the Stand

As previously told, Larned had worked with Jean at Rooney's, where feed and land plaster were sold. He testified that Jean had no problem unloading one-hundred-pound bags of feed and stacking them. Larned testified that Jean did not grunt when lifting the bags.

Burt Robinson Retakes the Stand

The Poland Central School principal testified that Miss Beecher had graduated from Cortland Normal School in 1912 and Poland had been her first teaching job. He testified that Jean had come to him to complain he was being persecuted by Miss Beecher, as other boys in the class behaved as he did yet did not get any punishment. Jean had told others that Robinson and Miss Beecher had threatened to send him to the House of Refuge in Rochester if he did not behave.

Dr. Charles G. Wagner, Alienist, Takes the Stand

Dr. Wagner was from Utica and then went to Cornell for his undergraduate studies before attending Albany Medical College and Columbia for his doctorate. He lived in Binghamton and had worked at the New York State Lunatic Asylum in Utica. While in Utica, he worked for several years at the asylum, where he was the first assistant physician and the editor of the *American Journal of Insanity*. He was appointed the superintendent of the Hospital for the Insane in Binghamton. He had taken a leave of absence to lecture in Europe on insanity. The doctor testified that he had 2,500 patients in Binghamton, and about 100 were imbeciles. Dr. Wagner would inspect and examine each one. The Herkimer County district attorney had requested Dr. Wagner come to examine Jean while in jail. The doctor went

to see Jean on three occasions. The members of the defense didn't want the doctor to testify as an expert, as they felt he had not enough experience with imbeciles. They were overruled.

Dr. Wagner visited Jean, accompanied by Dr. H.L. Palmer of Utica. At first, Jean would not answer any questions, saying that his attorney had told him not to talk. Upon examination, Dr. Wagner reported that Jean had dark brown hair, dark gray eyes, a medium nose, good teeth and a normal-sized head. It measured smaller than the normal twenty-one inches, but Dr. Wagner said that it was still in the normal range. This contradicted the opinion of the other physicians. He asked Jean to stick out his tongue, and it seemed coated in something but otherwise normal. Jean started talking to the doctor about criminal cases like those of Chester Gillette and the gun men from the Rosenthal murder, all of whom were executed for their crimes. Then Jean discussed the Leo Frank trial of Atlanta and the missing girl, Dorothy Arnold, who had been found supposedly alive at Bellevue. Dr. Wagner asked about Lida Beecher, and Jean refused to talk about her, only saying, "I'm old enough to go to the chair," meaning being executed in the electric chair. Dr. Wagner attempted to ask Jean questions, but the boy refused to answer and dropped his chin to his chest. Dr. Wagner put his hand on Jean's chin and said, "Jean, lift your head and look at me." The doctor testified that Jean then ran to the corner, stood looking into it and refused to talk. Dr. Wagner gave up and was leaving when he observed Jean talking, joking and laughing with the guards.

Dr. Wagner went back a few days later to examine and talk to Jean and this time was accompanied by Dr. Palmer and Dr. Willis E. Ford of Utica. This time, Jean said he would talk and tell them what they wanted to know. Jean chatted away about St. Vincent's, his crimes of theft and running away and the classes he took in school. He talked about his favorite speech, Lincoln's Gettysburg Address, and his favorite song to sing, "The Star-Spangled Banner," although he said he wasn't much of a singer. Dr. Wagner's testimony made Jean out to be an articulate and well-spoken young man. The doctor testified that Jean turned sour when he spoke of all the boys throwing papers yet only him being blamed and how Robinson had flogged him in the hall with a rubber hose many times, usually for ten minutes straight. Jean felt ashamed to be placed in a chair away from the rest of the kids for five weeks and had asked Miss Beecher every week if he could be back with his classmates and was denied. He then told the doctors that he got working papers and left school to work in a clothing mill in Newport, where he cut shirt cuffs, making eighty cents a day. He got angry when his

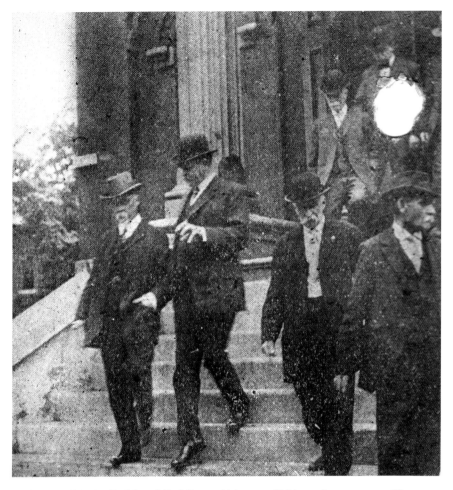

Alienists Dr. Pilgrim (*far left*) and Dr. Wagner (*right next to him*) leave the courtroom. The jurors next to them are leaving after a long day of testimony to eat their dinner. *Courtesy Herkimer County Historical Society.*

father kept his wages. He ran away but was caught, and his father had him placed at St. Vincent's.

Dr. Wagner testified that he then asked Jean about Miss Beecher, and Jean said he killed her in a frenzy and that "killing was wrong." They again measured his head and said it was normal and his eyes were normal, as was his tongue. The doctors then administered the Binet Test that the doctors for the defense had done. It was the same memorization of words and phrases, the same types of questions as had been done before, except these questions were for a twelve- to fifteen-year-old, with several for the fifteen-year-old.

Jean did reasonably well, according to Dr. Wagner. Dr. Wagner testified that based on his tests, Jean was not an imbecile. He also testified that Jean was sane at the time of the examinations. He disagreed with the defense doctors and declared that Jean had a mental age of sixteen years.

Court adjourned for the day.

Volume XII: The Trial Continues on Tuesday, May 26, at 9:30 a.m. at the Herkimer County Courthouse

Dr. Charles W. Pilgrim, Alienist, Called to the Stand

Dr. Pilgrim was the superintendent of the Hudson River State Hospital for the Insane for twenty-one years. He achieved his medical degree from New York University and trained at Bellevue Hospital before going to work at the Auburn Asylum for Insane Criminals. He then worked at the Utica State Hospital for the Insane before going to Hudson River. He took a break to study in Vienna for a year and then Munich, where he studied European methodology of treatment for the insane. On his way home, he visited every lunatic asylum in Great Britain. Before going to the Hudson River State Hospital, he had been the superintendent of Willard, the largest asylum in New York State, where he had 2,300 patients. Dr. Pilgrim had also been president of the New York State Commission of Lunacy. Out of 3,100 patients he had seen, he said only 100 were imbeciles.

He first saw and examined Jean Gianini on April 20 in the judge's room at the Herkimer County Courthouse. He had Dr. Wagner with him during the examination. Jean sat in a chair, was bent over and partially covered his face with one hand while twirling his hat with the other. He would not answer questions, so after a half hour, the doctors left. Jean also stuck out his tongue when asked certain questions. Dr. Pilgrim went back to see Jean eight days later and again had Dr. Wagner with him, along with Dr. Ford, except this time it was in the Herkimer County Jail. This time, Jean started to talk. He answered general questions about his education and said he got along with his teacher Miss Davis. He said he did not like Miss Beecher, as she picked on him, and he killed her out of revenge. Jean told the doctors it was wrong

to kill a person. He said Miss Beecher would not release him from being flogged with a hose by the principal and had said he was a "bad boy."

Dr. Pilgrim did a physical examination and determined Jean had clammy hands and misshapen ears but a normal-sized head. The doctor then testified that he tested Jean's taste with ammonia and peppermint, which he claimed can sniff out symptoms of hysteria. Dr. Pilgrim then conducted the Binet Test, as had all the previous doctors. He went through the test all the way to fifteen years old, and Jean passed. Dr. Pilgrim opposed the defense alienists who had declared Jean to have a mental age of ten years. Jean said to Dr. Pilgrim that he should get twenty years or life for the murder. This told Dr. Pilgrim that Jean was sane and able to understand and rationalize what he had done. The doctor testified that he knew of Jean's brother who had died and classified him as an "idiot."

Elmer Coonradt Takes the Stand

Coonradt was the justice of the peace for the town of Poland and testified regarding his conversation with Charles Gianini, Jean's father. He had a meeting at his office the previous year on August 18 with Charles, as well as Frank Newman and Jean. There was a document placed into evidence that had been signed by Charles Gianini on that August day that committed Jean to the St. Vincent's School. This showed that Jean was there and was told that his father was sending him to the school and not Miss Beecher. The murdered teacher's name was never mentioned that day in Justice Coonradt's office.

William Jones Takes the Stand

Miss Beecher had been a boarder at Jones's home while teaching at Poland Central School. This was a whimpering end to a contentious day of testimony by doctors, with the defense and prosecution battling in front of a hot and muggy courtroom.

Court adjourned for the day.

Volume XIII: The Trial Continues on Wednesday, May 27, at 9:30 a.m. at the Herkimer County Courthouse

The Defense's Closing Argument to the Jury

McIntyre addressed the jury, with Hirsch seated next to Jean. McIntyre started out by thanking the members of the jury for their patience and thoughtfulness. He said to consider almighty God when considering their verdict. He then talked of Lida Beecher's family and how her father, Reverend Beecher, had visited the homes of some of the jurors during the trial. That would cause a mistrial in our day and age. He told the jury that Jean admitted all the revolting details of his murdering a virtuous woman after luring her to her death. He told the jury they must do their duty and he had come there to plead with them to be fair and impartial to Jean. He stated that Jean had no motive and that imbeciles are incapable of understanding them and acting on them. He said the lapse of time between Jean being punished at school and the commission of the crime was essential, as it showed he didn't harbor a longtime need for revenge. He stated that Jean taking a life was an insane delusion from harboring a false belief. Lida Beecher was sweet and kind to Jean, while Robinson had beat him with a hose and Jean's father regularly whipped him, yet he didn't kill either man or harbor revengeful thoughts toward them. Jean's conduct was not that of a normal person.

McIntyre told the jury it was his holy duty to save Jean from the executioner. He described that if Jean were to go to the death chamber, he'd have his head shaved so the helmet could be attached along with the electrodes and his pants would be slit to allow his ankles to be shackled. The boy's bare feet would be placed on a wet mat. Jean would also be shackled to the chair, and the executioner would drop a handkerchief signaling the switch to be thrown, thus sending volts through the boy's body, killing him.

McIntyre reminded the jury that it was Robinson who got the chair from the attic and it was Robinson who made Jean sit away from the other children. Even with Miss Beecher pleading with the school principal not to place the young boy in that chair, he mandated the young teacher abide by his orders. And Jean was not expelled from Poland Central School; he voluntarily left the school. McIntyre called prosecutor Charles Thomas "sharp as an ax," which drew laughter from the jury and those in the courtroom.

McIntyre then said that he had dismissed any motive in the murder and now moved on to Jean's affliction by mentioning that when he said "insanity," he meant "imbecility." He mentioned the alienist Dr. Ford, who under cross-examination confirmed that Jean was not normal and some of his ideas were abnormal and imperfect. McIntyre was using Dr. Ford's testimony that Jean was abnormal to request an insanity plea. This was significant, as Dr. Ford was the alienist for the prosecution. Dr. Ford had testified that imbeciles exaggerate their being injured, and Jean's delusional mind caused him to exaggerate his treatment by Miss Beecher. "Dr. Ford testified that normal boys do not commit murder," said McIntyre. He then pointed to Jean and asked, "What kind of boy is he then?" He then asked, "How would you judge this boy?" McIntyre went to each juror and called them out by name, one by one, looking them in the eye and asking the same question of each one. He asked if the jury would feel justified sending this boy to death.

McIntyre then mentioned Dr. Ford having called Jean's brother Charlie an idiot and describing his mother as insane. The Gianini family had been cursed by the great God above. And Jean was also born idiotic. Would the jury further afflict and curse this family by sending an imbecilic boy to the electric chair? McIntyre was passionate as he fought for Jean's life.

McIntyre attacked the defense alienist Dr. Wagner by saying he was foolish not to believe the book of Gregor Mendel, who was the world's best alienist and had many schools named after him. Mendel's written works pegged Jean as insane. McIntyre poked holes in the testimony of Dr. Wagner, saying the man was not truthful, dodged questions and was not an expert on imbecility. He told the jury the doctor was an expert on the insane but not imbeciles. He asked the jury to compare this to Dr. Goddard, who had seen twenty-five thousand imbeciles in his career.

He then called Dr. Suiter of Herkimer a decent, truthful man who was respected worldwide and had testified that Jean was an imbecile. He commented that Charles Thomas had attacked the lovely old gentleman but didn't mean it, as Thomas knew in his heart Dr. Suiter was a very great man. McIntyre then said Dr. Wagner pestered Jean to admit to the crime and confess and he should be ashamed of himself for pressuring the lad. McIntyre then tried to discredit Dr. Pilgrim, who he said had limited experience with imbeciles, as he only treated six while at Willard Hospital. Dr. Pilgrim also had written that Jean had "retarded mental development."

McIntyre said that the evidence showed Jean was mentally ten years old, and he felt that you cannot send a boy that young to the electric chair. "The law says a boy between seven and twelve cannot commit a crime," he said,

addressing the jury. The sharp defense attorney then said that he didn't think much of the Binet Scale until he learned more from the doctors at the trial, but he had become a believer in it. The allowance of the Binet Scale was a huge victory for the defense.

McIntyre told the jury that Jean's mother was a pleasant and beautiful woman with religious devotion and many admirers before the curse came upon her. Her mental decay had flowed into Jean, who was abandoned and shuffled around as a feeble infant with no proper parenting or guidance, which didn't help his walking and speech. McIntyre said Jean was allowed to run the streets of New York City with no supervision, which made him wild and with no moral influences.

McIntyre mentioned that Dr. Bernstein had not been brought in by the prosecution or the defense; the doctor came on his own, examined Jean independently and declared the boy an imbecile.

McIntyre's last plea to the jury was to have God almighty guide them in their deliberations and not send this unfortunate creature to the electric chair. The judge then allowed a brief recess for the jury to recover before the prosecution presented its case.

The Prosecution's Closing Argument to the Jury

District Attorney Farrell addressed the jury with Charles Thomas watching from the table. He told the jury that the defense had presented a poor case. He stated that Jean was an "urban cultured, refined and up-to-date New York City" boy when he came to the village of Poland. He said the alienists who had been called to testify for the defense were trying to trick the jury, that they were duping them by using "dazzling verbosity." Farrell called the theories by the defense "mythical" and "mysterious" and said that the jury was too smart to fall for it. He stated that the crime had been committed in the "tracery of night" on a lonely road. He reminded the jury that Jean confessed to the murder only when authorities had told the lad they had the goods on him. Farrell said there was nothing strange about sending Jean to the electric chair, as his age of sixteen years old was within the law. He said Jean had lured Lida away to kill her by acting jolly and interested in going back to school. Her desire to help Jean cost Lida her life. She was a "country girl" not used to the wise ways of Jean the "city chap." Farrell stated to the jury that the entire imbecility defense was a fallacy and that Jean had not been possessed by the devil.

He then said to the jury that they were not feeble-minded and could see through this sham of a defense. Farrell said they could not find Jean not guilty by reason of insanity, as he'd end up doing six months in an asylum, be released and commit another murder. Jean would strike down some poor, trusting, good girl. Farrell paused and then stated that Jean had bloodied, battered and stabbed a poor innocent teacher. He then told the jury their duty was to send Jean to the electric chair to protect their daughters, their wives, their sisters. "Send that worthless boy to the fate he deserves," said Farrell.

The prosecutor then stated that the jury must not be swayed by the defense experts. He reminded them that we all can look around our towns and villages and see people who are strange, funny or peculiar, yet they don't kill people. Farrell then tried to discredit the Binet Test. He said believing in this test is a travesty of justice and quackery. He also said that using stigmata to determine imbecility is wrong, and that people come in all shapes and sizes and are not imbeciles because of these body and head shape differences. Just because Jean walked with a gait and had funny body dimensions did not make him an imbecile.

He then said that Jean had behaved for Miss Davis in Poland Central School for years; if he was an imbecile, wouldn't he have misbehaved at that time? Farrell called Jean a "wise guy" who traveled around just fine and had to keep being brought back by his father. Jean had gotten along just fine with everybody.

Farrell then told the jury that Jean was cold and calculated as he plotted to kill Miss Beecher, took advantage of her weakness to help him and lured her to get his insidious revenge. The prosecution made Jean out to be a cold and calculated murderer who sat waiting with a knife and monkey wrench for Miss Beecher to be available to be murdered. Jean lured her up the lonely hill where no house stood, but her discovery of that fact came too late for her poor soul. At that point, Farrell picked up the monkey wrench and demonstrated Jean swinging it. The defense tried to object but was overruled by Judge Devendorf. Farrell told the jury that Jean was not an imbecile but a coward. He then set down the wrench and picked up the knife, declaring, "Jean wanted to finish her. This person is as cunning as any criminal who ever lived."

Farrell then said a criminal mind murders, not an imbecilic one. He said Jean only confessed when he realized they had solid evidence that he had done the crime. Farrell tried to say that all Jean's earlier antics had been just a boy being a boy—the mud pie eating, the scrapes with other boys, the

pranks with girls and his sister. "He's a natural normal boy," said Farrell to the jury in the sweltering hot courtroom.

Farrell then ended his address to the jury by telling them to use their common sense and their wonderful influence to send a message that would show good over evil in our country. "Gentlemen, I thank you," were his last words.

Judge Devendorf Instructs the Jury

The judge told the twelve men of the jury that the State of New York had charged Jean Gianini with the crime of murder in the first degree and that on March 27, 1914, Jean had taken the life of Lydia Lui Beecher. The judge told the jury that the proof had been provided that Lida had been murdered by Jean. They must do the unpleasant duty of determining the life of the young man accused. "You must give it your best and most faithful effort," said Devendorf. He told the jury that it is important that a man shouldn't suffer the degradation of a conviction if he is innocent, and if the person is guilty, he must suffer the proper punishment. The jurors must carefully weigh all the evidence and not be influenced by anything other than that. The judge asked the jury to put away fear and sympathy and do their duty.

The judge said a child under the age of twelve is not capable of a crime, but a person above that age is responsible for his crime. He told the jury that guilt of first-degree murder was punishable by death, and murder in the second degree or manslaughter in the first degree was punishable by up to twenty years in prison. Judge Devendorf said a lot of these degrees have to do with premeditation, or passion in the committing of the crime. He then told the jury that a man cannot be found guilty of a crime if he is an idiot, imbecile, lunatic or insane. This can be determined by whether the person in the preceding state did not know the nature or quality of the act he was doing or did not know the act was wrong. He did say though, "The law does not shield the mentally retarded from the consequences of their misdeeds." The judge then instructed the jury that their options were to find Jean guilty of murder in the first degree; innocent, which meant he would be acquitted; or guilty by reason of insanity. The jury retired at 5:42 p.m. to begin their deliberations.

After meeting all that night and into the next day, the jury returned to the courtroom at 10:15 a.m. on May 28 and told the judge they had not reached a verdict. Mr. Jordan was the lead juror and asked the judge to read for

Justice Devendorf *(far right)* leaving the courthouse and passing courtroom spectators. The trial was conducted in front of a packed courtroom. The popular judge is carrying his robe over his arm. *Courtesy Town of Russia.*

them again the different verdicts they could consider. After the judge read them, the jury went back into session and came back out at 2:43 p.m. with a verdict. The press reported that the smirking Jean had been replaced by a stoic stone-faced person who looked a twin to the Egyptian sphinx. Jean's life was in the hands of the jury. In front of a packed courtroom, and with Jean Gianini standing on shaking legs, Judge Devendorf asked the jury if they had reached a verdict. Mr. Jordan said yes and stood and read the following:

The Shocking 1914 Case of a Vengeful Student

"We find the defendant in this case not guilty as charged in the indictment. Therefore we acquit him on the ground of criminal imbecility." McIntyre stood and asked the judge to endorse the order that would send Jean to Matteawan State Hospital for the Criminally Insane. The judge agreed and asked the sheriff to take custody of Jean until June 1, at which time he would be transferred to that facility.

Chapter 5

THE JURY

The 12 men who sat on the jury were picked from over 150 who had been interviewed, and they would go on to be criticized for their verdict, with many feeling the local Herkimer County residents had been mesmerized by slick New York City lawyers and alienists. Selecting the jury was a tedious process, as after two long days, only 9 had been selected. It was proving difficult, as many were farmers and it was planting season. The judge was getting impatient at the lengthy process and reminded prospective jurors to tell the truth. Some were claiming illness, that they couldn't be biased against a Roman Catholic and other reasons to get out of serving. There were at least 100 people on the call to testify list, and it was being said that the trial could last three weeks. This put a strain on most jury candidates. Many were dismissed for providing the most simple answers to easy questions like "Did you read about the case in the newspapers?" A simple "yes" might get a prospective juror excused. Webster Rasbach, forty, a clerk in the town of Herkimer, was selected after he stated he had no bias and then went on to state, "I suppose no man can be placed in so ludicrous a position that no person could be found to defend him."

It was witnessed by many reporters in the courtroom that during jury selection Jean Gianini sat with his head down, picking at his fingers and nails, and only occasionally would pick up his head and look around. Most of the questioning of the prospective jurors or "talesman," as described in the press, was done by defense attorney McIntyre and prosecutor Thomas. Their styles could not be more different, with

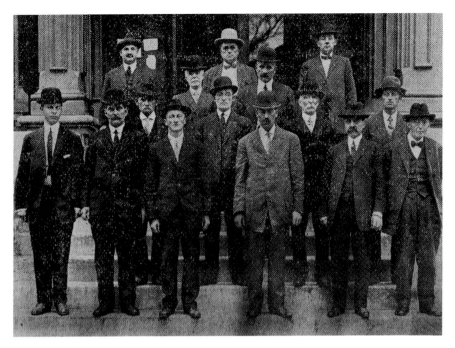

The jury members of the Jean Gianini trial would receive praise for their thoughtfulness and criticism for failing to carry out justice. *Courtesy Herkimer County Historical Society.*

McIntyre smiling, jovial and gently asking questions while Thomas was stern, impatient and grilled all is if they had something to hide. The courtroom was packed, and reporters mentioned that the mass of young ladies in their spring attire added some color to the drab interior. It seems Jean had a large group of curious young ladies all craning their necks to view the lad with their young, wide-open, beautiful eyes. On one break from the selection, Jean was observed outside the court smoking a cigar and reading a newspaper that had holes in it. All articles pertaining to the case had been carefully cut out.

There is no doubt that criminal cases attract all kinds of curious people gawking and rubbernecking inside and outside the courtroom, and even in 1914, sometimes the interactions were plain odd. The following letter was sent to the court as the jury selection was underway. Incredibly, this letter was read aloud and passed around. Reporters were allowed to look it over, and the contents were printed in many newspapers. The letter reads as follows:

The Shocking 1914 Case of a Vengeful Student

I take pleasure in writing you to let you know that I came into this world November 18, 1850 drunk and have been drunk ever since till one month ago, which I can prove to a judge and jury without a doubt. I am going into the lecture field to tell young men the difference between pure water and alcohol beverages. Now, if you think you can use me in defense of young Jean Gianini I will come on one hour's notice and I will make no charge, only my expenses, while in your employ. If you see that I have done your case good you can pay me a small compensation for my services, as I have to work for my family's support. I will give out information that will surprise the Court and the medical mob and make my argument so clear that a school boy can get the meaning.
C.W. Johnston
303 East Washington Street
Syracuse, NY

Finding Jean not guilty by reason of insanity brought forth a lot of criticism of the jury in the public and newspapers. The fact of the matter is that after reading the entire court transcript, you can see both the prosecution and the defense presented credible, compelling cases for guilt and exoneration. The jury would state that they knew if Jean was found not guilty by reason of insanity, he'd be committed to an asylum and never be allowed to walk free. They felt this was best for Jean, as the alienists for the defense had convinced them Jean was an imbecile. It was the results of the Binet Scale that seem to have won the jury over, plus Jean's physical nature, his delayed speech and walking as a child and his irrational behavior that occurred throughout his entire life. We can look back now and say the jury was a brave group of men who must have known their decision would be met with scorn. The people of the town of Russia and village of Poland loved the Gianini family and gave them solid support, but others in Herkimer would view the matter differently.

The jurors were Henry Sterling, sixty-five, millworker, one daughter and from Dolgville; Seward G. Bellinger, forty-nine, farmer, a bachelor and from Danube; Joseph Frinkle, sixty-eight, farmer, married with three children and from Cold Brook; Terrance O'Day, Herkimer; Luke Byrnes, sixty, stonemason, married with three sons and from West Winfield; Edward J. Turner, thirty, farmer, married with two children and from Columbia; Warren W. Fenton, twenty-six, typewriter assembler, married with two children and from Mohawk; Webster Rasbach, forty, grocery clerk, married with two children and from Herkimer; Horace J. Nichols,

The jury delivers the verdict. *Drawing by Andrew Buffington.*

thirty-eight, cheesemaker, married with two children and from Norway; George Homerighouse, thirty-seven, one son and from Salisbury; Frank A. Jordan, fifty-one, laundryman, married with four children and from Herkimer; and Bronson Plattner, fifty-five, feed store manager, married with five children and from Frankfort. Jordan was the foreman and lead jury person whose job it was to stand and read the verdict to the hot,

packed courtroom. It was reported that throughout the trial, the members of the jury had stern and worried looks on their faces. There was no doubt the case was intense on both sides.

Interesting note: women were not allowed to vote in our country until 1920, and the jury was made up of all men. During the testimony, there were ladies present when all the gory details were discussed, yet when it came time to discuss Jean's "self-abuse," the women were all asked to leave the courtroom.

A few moments after the verdict was read, attorney McIntyre and Jean's father, Charles Gianini, met with the entire jury in the lobby of the Palmer House, and McIntyre assured them they had made the right decision, as Jean would be sent to Matteawan Asylum for life. Charles assured them he would never petition for his son to be released so he could never again be a menace to society.

The jurors were twelve brave men who spent a lengthy time—twenty-one hours—in a small, hot room considering their decision and were criticized for it, with many Herkimer citizens mulling around the streets all night and into the next day uttering disbelief. Jurors were accosted and called out on their incompetence. Bitter criticism was poured into the ears of the jurors as they passed along the streets of Herkimer. Defense attorney Hirsch reassured the jurors as they were stinging from the backlash, telling them the public would change their minds once they read the facts of the case and realized the decision the jury had come to was the only logical solution. The brave jurors knew they would be stung with criticism, yet most in the press dubbed them brave and fearless men.

Jean Gianini was as surprised as anyone at the verdict. He had been getting a special guarded escort back and forth from the jail by James Hinman. On his way into the courtroom to hear the verdict, Jean had told Hinman that he only had one dollar to his name and asked if the guard would bet a dollar that he would be found guilty and fry in the electric chair. Hinman refused to take the bet, as he had agreed with Jean that he was heading to Auburn to be put to death. Jean's father was also surprised and said, "I'm very happy. It was proven my son is an imbecile."

Throughout the trial, Jean would not speak to reporters but would just look and smile. He even winked once when they called out to him. But he entertained reporters in his jail cell after the verdict. They reported that a woman had sent Jean a large arrangement of pink roses that emitted a wonderful smell in his cell—the same cell Chester Gillette had sat in before he was sent to Auburn to die in the electric chair. Jean was talkative to the

collective reporters and said, "If a kid told me he was going to kill his teacher like I did, I'd show him that it is wrong. Every kid's old man ain't got as much money as mine and they might not get out so lucky." Jean admitted he was lucky but said he had been prepared to go to the chair with no protest. Jean then commented on prosecutor Charles Thomas, saying, "I'll bet old Thomas is madder'n hell because he wanted to kill me." Jean said he didn't think his father liked him much, but his sister Moffie was his best friend. Jean told reporters that if given the chance he would never have committed the murder and would never do such a thing again. The reporters told Jean that only two of the twelve jurors wanted him to be found not guilty, and over long hours, the rest had been turned to provide the shocking outcome.

The *Ilion Citizen* printed a scathing review of the jury and its verdict. It said that never had a verdict been rendered in the history of Herkimer County that gave such great dissatisfaction. "Even God almighty doesn't know what a jury will do," was the quote at the top of the editorial. The *Citizen* quoted Jean himself stating, "How in the hell did they arrive at that verdict?' Words thrown in the editorial included "astonishment" and "disgust." It stated that Gianini was as guilty as a dog and said Jean had intelligently and deliberately murdered Lida Beecher. "It gives Herkimer County a bad name that these jurors could be duped by a slick high-priced New York City lawyer," blasted the *Citizen* in print. It said this miscarriage of justice placed a shadow on the twelve jurors that made them look ridiculous. The *Citizen* called Jean a "young devil." Jean had stated that blood on his jacket sleeve was from a rat he had killed and not Miss Beecher. Based on this attempted deception, the *Citizen* claimed that Jean knew his deed was wrong and tried to cover it up. The *Citizen* stated that in any community you can find people who are cranky, odd, extreme, unbalanced and might be called "imbecile," yet they do not commit murder. However, the *Citizen* did say that if you were splitting hairs, yes, Jean Gianini was an imbecile. Further proof of his being an imbecile was the insensitive poems he left in his cell when he was transferred to Matteawan.

In an odd twist, the jurors would meet annually and have a reunion. People of Herkimer County protested, but this was ignored. It's not known how many years after the verdict they continued to meet.

If one were to read the entire transcript from the trial—close to four thousand pages—and read the alienists' testimony and the results of the Binet Test, one can have no doubt that the jury did the **right and just** thing with the not guilty by insanity verdict. Instead of **using words** like "shame" and "disgust," the jury needed to be called brave, **compassionate and** just.

Chapter 6

CHESTER GILLETTE CONNECTION

Jean Gianini had an obsession with fictional stories of bad men and robbers, but he also enjoyed nonfiction crime stories. He was especially obsessed with the criminal case, trial and execution of Chester Gillette. Chester had murdered a beautiful young woman, Grace Brown, and created a national obsession as the rich young man who exploited his pregnant girlfriend and lured her to her death at Big Moose Lake in Herkimer County. Chester Gillette had been found guilty of first-degree murder and was put to death in the electric chair at Auburn Prison in 1908. The entire affair inspired the book *An American Tragedy* and the award-winning movie *A Place in the Sun*. Jean had no fear of the electric chair and had bragged as such to the alienist Dr. MacDonald as he was being interviewed in the Herkimer County Jail cell that his obsession had also occupied. "You would be sent to the electric chair if found guilty. Do you know what that means?" asked Dr. MacDonald. Jean replied with a smile, "Sure I do, but I ain't afraid of the chair. I ain't a-goin to be afraid of nothing. Of course I would rather go to prison than to the chair but I ain't afraid. I done it and that's all there is to it." Jean's cell—Chester's cell—had a locked inner cell with a small adjacent room that had a table and chair with an ashtray so he could smoke. He smoked a lot in the cell. In another odd twist, Judge Devendorf's first murder trial after taking the bench had been the Chester Gillette case, and now he would preside over Jean's.

During the jury selection for Jean's trial, Frank B. Peck was part of the jury pool and was revealed to have been the station agent up at Big Moose

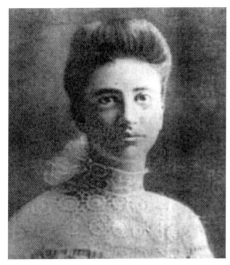 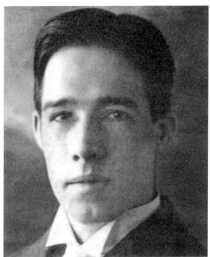

Left: Grace Brown, the beautiful young woman murdered by Chester Gillette. *Courtesy Herkimer County Historical Society.*

Right: Jean Gianini was fascinated with the killer Chester Gillette, who fried in the electric chair. *Courtesy Herkimer County Historical Society.*

Lake when Chester Gillette murdered Grace Brown. Attorneys on both sides kept discussing Chester Gillette, with Jean leaning forward to take in every word. Peck would not be selected for the jury, but it was another connection to Jean.

Reverend Beecher referenced Jean's obsession with the Gillette case and others that he had read about in books glamorizing criminal deeds and glorifying violence. When Jean was sitting in his cell, his beloved sister visited him and brought him fruit, candy and a stack of what he called his "funny books." These were fictionalized accounts and nonfiction books on murders, crimes and mayhem. Before Jean had killed Lida Beecher, he spoke in length to her and her sister-in-law about Chester Gillette, the murder and the electric chair. He had an obsession with crimes that led to capital punishment. He had read what defense attorney McIntyre called "wild and wooly tales." Reporters would write all about Jean's obsession with crime novels, robbers and blood-letting bad men. The public knew Jean had been obsessed with and captivated by the Chester Gillette case.

Jean's case and trial would prove lengthier and costlier than Chester Gillette's. Some of the listed court costs for Herkimer County were $8,550,

The Shocking 1914 Case of a Vengeful Student

Jean would be placed in the same jail cell at the Herkimer County Jail as famous murderer Chester Gillette. *Photo by Dennis Webster.*

which included $2,500 to draw the jury, $1,500 for called state experts and $1,500 as the fee for prosecuting attorney Charles Thomas. When all was said and done, the Gianini trial cost Herkimer County $15,000.

Jean would not follow his obsession to the electric chair and would instead spend the rest of his life in mental health institutions.

Chapter 7

JEAN GIANINI GOES TO MATTEAWAN

At the end of the dramatic trial, on May 29, 1914, Jean was sentenced to the Matteawan State Hospital for the Criminally Insane. He was held in the Herkimer County Jail until Monday, June 3, when he was taken to the train station and then to the facility. He spent the next fifty-two years there, until 1966, when he was transferred to Kings Park Psychiatric Center. He stayed in that facility until he passed away on February 22, 1988, at the age of ninety.

Many citizens of Herkimer County felt that Jean should have been found guilty and sent to Auburn to be put to death in the electric chair for murdering his teacher, Miss Lida Beecher. The press roasted the verdict and the jury, with the *Skaneateles Free Press* stating in an editorial, "Nobody had thought of this perverted criminal and assassin as mentally defective until his defense counsel took up the idea as a desperate chance to save him." There were many in the town of Russia who felt Jean was a young man in need of mental health assistance and treatment. There were also some who felt that Jean had not committed the crime at all and had confessed under duress.

Matteawan State Hospital was a large facility that held the criminally insane and was nestled on the banks of the Hudson River near the Fishkill Mountains. It opened in 1892 and was built to hold 550 patients. Previously, the criminally insane had been housed at a facility in Auburn, but those patients had been relocated to the Matteawan facility. There were other facilities for the criminally insane, but Jean was being sent to a high-security facility. The facility had adopted the "moral treatment" for

Murder of a Herkimer County Teacher

Left: Jean's certificate of death, with a mistake identifying his sex as "female." He lived to ninety years of age and passed away never having gained his freedom. *Courtesy Herkimer County Historical Society.*

Below: Matteawan State Hospital for the Criminally Insane. *Drawing by Andrew Buffington.*

the insane that would provide patients with occupations. They were given a chance to work making baskets, cooking and doing maintenance and working on the farm. Seven hundred acres of the grounds were dedicated to agriculture.

Jean had a visitor in 1928, when he was closing in on thirty years of age: Little Falls, New York chief of police James J. Long. He saw Jean walking the grounds outside the facility, walked up to him and said, "Hello, Jean." Jean refused to answer and quickly darted away. He stayed back and gave quick glances at Chief Long. The authorities at the asylum reported that Jean was the same way with the staff and his fellow patients. He was generally silent and morose. The authorities told Chief Long that Jean would have no hope of release, as he would never be mentally stable enough to make a safe return to society.

Lawyers across the United States studied the case of Jean and his escape from the electric chair by reason of insanity to assist their own clients. The press would dub Jean the "intellectual imbecile."

Chapter 8

THE CRIMINAL IMBECILE

Dr. Henry Herbert Goddard used his experience from the Jean Gianini murder trial to write his book *The Criminal Imbecile*. The book was published in 1922, eight years after the trial. He was not a medical doctor but had his PhD in philosophy. In the book, he profiled three "remarkable" cases of murder but led with, and made a major point of the book, the trial of the century, in which Jean was pronounced not guilty by reason of insanity. Dr. Goddard wrote the book as the director of treatment research at the Vineland Training School, the first psychological research lab in the United States. At the time, it had a working farm that was student operated. In 1888, it had gone by the name the New Jersey Home for the Education and Care of Feebleminded Children. Jean's entire insanity defense had come from his being declared feeble-minded, moronic, idiotic and an imbecile. Jean's case was considered the first to use the Binet Test. Dr. Goddard refered to Jean Gianini as a "high grade criminal imbecile and a loquacious loner." Dr. Goddard stated that his book should be a reference tool to successfully defend the criminal imbecile in court.

Dr. Goddard started his book by presenting the case of Jean Gianini. The prosecution and the Poland and Herkimer County community had viewed Jean as a cold-blooded killer and fiend of the evilest sort, while the defense had successfully claimed he had the intelligence of a ten-year-old child. The not guilty by reason of insanity verdict was deemed remarkable by Dr. Goddard, considering the public's perception and the jury being of local stock. He said feeble-mindedness is the same as insanity, and a high-grade imbecile

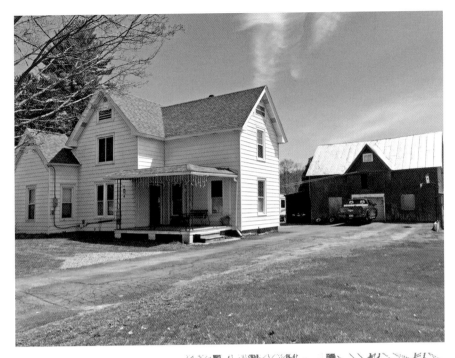

Above: The Gianini home as it appears today. *Photo by Dennis Webster.*

Right: Jean awaits his fate in his cell. *Drawing by Andrew Buffington.*

like Jean is very prevalent in our society but misunderstood. Dr. Goddard explained the murder and that Jean didn't understand the ramifications of his confession. He had stated that Miss Beecher had humiliated him in school so he sought revenge. Dr. Goddard said the mistake made by the prosecution was that they did not take the insanity plea seriously and gravely misjudged Jean being deemed an imbecile. He stated that there is no doubt that Jean Gianini was an imbecile and not insane, and the misunderstanding of the difference drove the public to anger after the innocent verdict.

This case study was Dr. Goddard's attempt to prove that the verdict was a correct one. He said that being an imbecile made Jean unaware of the consequences and ramifications of his words and deeds. Jean was telling people that he was going to get even with Miss Beecher even though he had been out of her classroom for almost a year. Jean had been sent away to St. Vincent's School by his father because of his behavior and propensity to jump and ride on freight trains. He'd also been seen to have had the rusty pipe wrench—the tool of murder—in his possession, bragging that he had a use for it. Jean then walked with Lida to the place of her murder, with many seeing them together. Only an imbecile, according to Dr. Goddard, would do such things. Jean had no real motive. Also, Dr. Goddard felt that no sane, normal person would dictate and sign the confession that Jean put forth. Only a moron would do such a thing.

Dr. Goddard had examined thousands of imbeciles and morons and said that all had the same traits as Jean and that he had a mentality of between three and twelve years old. Jean was classified as a "high-grade imbecile" and not a complete idiot like the low-grade imbeciles who populate asylums and have every care accommodated. Dr. Goddard said that the public had a hard time accepting the verdict, as most don't know or understand what a high-grade imbecile is. The crime he had committed proved that Jean was not a normal boy. He had undergone an arrested development, and his mind stopped developing at the age of ten. Dr. Goddard even stated that Jean was not attempting to get away after committing the murder but was wandering like he had done many times, looking for a train to jump. Walking down the tracks to Newport was nothing more than wanderlust. He was not in a rush and took no precautions to hide, as many had seen him. Jean confessed to brag and be proud. He had been told that his words would be used against him, and he still talked on and confessed. No normal, rational person would do this, according to Dr. Goddard.

One interesting fact was that Jean admitted that he had sharpened the knife in anticipation of the murder, yet the doctor did not consider this

premeditated but, rather, due to Jean's imbecility. Dr. Goddard claimed that perhaps Jean had lured Lida up that hill for sex and not to murder her. He was sixteen, and sexual passion is strong. Being an imbecile would cause Jean to bypass the norms and folkways of courtship and leap into sexual deviancy where he could satisfy his sexual appetite illegally. This is the way of the imbecile, according to Dr. Goddard. Proof of this was that Jean masturbated. He was not conscious of what was driving his sexual desire. His pushing and pulling of girls, teasing and pulling their hair were all part of the imbecile nature of female courtship. This was all early twentieth-century thinking on the part of Dr. Goddard. He then claimed that Jean had previously lured a few young girls into the woods to play Indians and convinced them to remove all of their clothing, as Indians ran around naked. He said that this showed Jean's lack of judgment and that he was an imbecile coward.

Dr. Goddard stated that Jean stabbed Lida twenty-four times, which is an astounding number and overkill. It's interesting that the doctor claimed Jean had no proper thought to the crime, yet Jean stated he grabbed Lida by the leg when he dragged her off the road because he feared leaving fingerprints on the body that could be traced back and lead to his guilt in the crime. Is that not the planning of a crime? Dr. Goddard felt that Jean picked up his means and methodology by reading of crimes that had been committed by others. The doctor claimed Jean had to have been an imbecile, as he failed to cover up his tracks in the snow, and that he had not read about that in his crime books so he didn't know to do that part. Couldn't it be that he was pathological and not necessarily an imbecile? According to Dr. Goddard, an imbecile like Jean doesn't have remorse, and that's why he was able to go back home after murdering Lida and sleep soundly in his bed. Jean didn't even run away like a normal boy would have done. The following morning, he casually strolled the tracks to Newport, with nary a care in the world.

Dr. Goddard said that all the alienists who interviewed Jean in jail said he relished the attention and wanted to know how his picture looked in the newspapers and what they were saying about him. Even in the courtroom, Jean had acted like a child, happy to get the attention, and many times ignored warnings from his lawyers. He had no fear, sorrow or horror at what he had done. Dr. Goddard stated that only an imbecile would act in this manner. Jean preferred to eat his soup in his jail cell and not speak to those who were there to help him; instead, he'd ignore them and happily hum to himself while slurping his food. He'd say that the Herkimer County Jail was better than St. Vincent's.

The Shocking 1914 Case of a Vengeful Student

Dr. Goddard wrote about childish pranks that Jean had committed that would be common to boys under the age of ten but not a mature sixteen-year-old. In one instance, he placed salt on the tails of pigeons in order to catch them. He also went to the village blacksmith, Peter Back, and asked him for "strap oil." He teased and bullied the other children, and his former superintendents testified that Jean acted like a moron and imbecile while in their care. His characteristics were common and in place with other boys suffering from the affliction.

Dr. Goddard then got into Jean's results of the Benet Test and how he had trouble taking direction, drawing diagrams and remembering lines. The doctor stated that the prosecution failed to understand that the Binet Scale does not have simple answers and grades that point to imbecility. Interpretations vary based on many factors and answers; he called it "sophistry" that they failed to understand that point. A huge counterpoint was the fact that Jean had been an excellent student through fifth grade, with many perfect scores on exams. Dr. Goddard stated that Jean fell off after sixth grade because his being an imbecile made it impossible to excel past that level. The prosecution had stated that he was a wild boy who preferred to be truant and lazy in his work, and that's why his grades plummeted.

The final conclusion that Dr. Goddard gave as proof that Jean Gianini was an imbecile was that Jean was a nervous, impulsive, irritable, loquacious type, fond of showing off and the excitement that it brought. His interest in crimes, and being an excellent reader, thrilled him and stoked his imbecility to manifest in murder. The doctor stated that it was easy to understand the public's outcry of injustice, as they did not understand those who are feeble-minded. The general public was ignorant in mental health matters and failed to recognize the high-grade imbecile.

Additional Observations from Dr. Goddard's Case Study

The book itself is incredibly interesting, and Dr. Goddard adds items not brought up in trial or based on his observations of Jean. He mentioned that until medical science can treat people who are imbeciles, they belong in institutions for life and not executed in an electric chair. The doctor said that the jury in Jean's trial had been confused, as they felt they either had to place Jean in the electric chair or find him innocent. He said Jean loved

the limelight so much that his entire testimony was probably full of lies, unless able to be corroborated with evidence. Jean was acting on impulse and instinct rather than responsibility, as taught by his parents and expected in society. Dr. Goddard said the imbecile like Jean knew exactly what he was doing, unlike a lunatic, who acts blindly. Jean's condition meant that although he knew what he was doing, he did not have the quality of mind to know that what he was doing was wrong. He lacked mental capacity, abstraction and experience—all common in the high-grade imbecile category.

So what punishment did Dr. Godard feel the murderer with high-grade imbecility should get? He stated that they are not guilty of murder but require some punishment to satisfy society. We cannot have innocent citizens being killed. It would be easy to destroy the imbecile. Dead men commit no crimes. Society feels safe. But Dr. Goddard was against the death penalty, especially for the mentally ill like Jean. He felt that Jean and others with the imbecile affliction should be put away for life in institutions where they cannot repeat their crimes but can be treated. It would never be safe for Jean to be at large. Jean was dull and backward at school but did not belong tied down to die in an electric chair. Dr. Goddard stated that not only should the high-grade imbecile like Jean Gianini be placed in an institution for the insane for the rest of his life but he, and people like him, should be surgically rendered unable to procreate. He proposed a reduction in the birthrate of these individuals. He felt that we should use our intelligence to eliminate the problem at the root.

Chapter 9

THE BINET SCALE

The Binet Scale was the first developed result of a test to measure a person's intelligence. The first practical intelligence tool, called the Binet Test, was invented and used in France by Alfred Binet (1857–1911). The test had only been in use since 1905, when Binet published his first article on the subject. It had been in use in the United States since 1908 but only in asylums and not in court cases. The Jean Gianini murder trial was the first time in the history of the United States that it was used in a murder trial. Dr. Henry Herbert Goddard had applied this test in thousands of children in asylums before he used it on Jean Gianini. The Binet Test was used mainly to acquire the mental age of a child rather than the birth or chronological age. Jean, who was sixteen at the time of the test, was determined to have a mental age of ten. This result was highly controversial and debated at the time, as the test had not been in practice for very long. The prosecution fought fiercely to keep it out of the trial but was overruled. Dr. Goddard's and Dr. MacDonald's testimony was powerful and worthy, as the men had the medical pedigree and experience in analyzing children with lunacy and imbecility.

Dr. Carlos MacDonald administered the test to Jean Gianini when he was in the Herkimer County Jail. Dr. MacDonald would recite phrases and ask Jean to repeat them. He'd state other items and ask Jean to write them down. He'd ask simple arithmetic questions like, "What is seven times nine?" Jean struggled in all areas, and the result was Dr. MacDonald testifying that Jean had the mental ability of a ten-year-old and was an imbecile.

Dr. Goddard applied the test as well. His was slightly different than that of Dr. MacDonald. He asked Jean to use the words "Delaware," "money" and "river" in a sentence. Jean replied, "The Delaware River runs through the money center of Philadelphia." He gave Jean scrambled words and asked him to re-create the original sentence. Jean struggled at this task. Jean was able to draw simple shapes he'd been shown, like a diamond, a circle and a square. Dr. Goddard then did word association and told Jean to say the first word that came into his mind. Jean remained silent and barely replied to any of the words. He gave Jean examples of anger and when it was appropriate to use them, and Jean struggled with some of his answers. One question was, "A painter falls off a ladder, breaks his neck and dies. He will not get better. How does that make you feel?" Jean smiled and replied, "I'd like to have seen him fall. But he did it on Friday. That's an unlucky day, especially if it's the thirteenth." These answers told the doctor that Jean had a lack of empathy and his reasoning was not normal. He then asked Jean what time it was by explaining where the hands were located on the clock face, and Jean could not answer. Jean told the doctor that he liked to read at home, with *Peck's Bad Boy* being his favorite. Jean could not recall any of the story. Dr. Goddard then gave Jean five similar tin boxes that varied by weight. He asked Jean to arrange them from lightest to heaviest. It took Jean a few tries to get it correct. Jean was again shown pictures—over one hundred—and with each one the doctor would put it away and ask Jean to state what was in the picture he had just looked at. Jean was successful in only a third of these questions. Dr. Goddard spent a long time with Jean and was very comprehensive in his examination. He applied the complete Binet Test.

The following is a sampling of the questions the alienists administered to Jean while he was in the Herkimer County Jail awaiting his trial for murdering Lida Beecher. These questions were taken right from the court transcripts. Jean was asked hundreds of questions by multiple doctors for the defense and the prosecution. The following is not the complete Q&A but selected questions and answers that might show Jean's personality.

Dr. Carlos MacDonald, Dr. A. Walter Suiter and Charles Hane, counsel for the defense, were present on April 14, 1914, and asked some of the following:

> Q. *What is your full name?*
> A. *Jean Martinette Gianini.*
> Q. *How long have you worn glasses?*
> A. *Five years.*

The Shocking 1914 Case of a Vengeful Student

Q. Do you smoke?
A. Yes, as many as I can get.
Q. Do you eat here?
A. Yes. I have a cup of broth twice a day.
Q. How many ten cent pieces in $2?
A. Twenty.
Q. Were you punished at St. Vincent's?
A. Yes. I got rapped on the hands 18 times for breaking the rules.
Q. Ever get in a fight?
A. Yes, lots of them.
Q. Are you easy to get angry and get into a fight?
A. Yes. If they want to fight…I fight.
Q. Did you commit a murder?
A. Yes.
Q. Who did you kill?
A. Lida Beecher.
Q. You killed her for revenge?
A. Yes.
Q. What did you kill her with?
A. A knife and a monkey wrench. [Jean laughs]
Q. You laugh when you say that, do you think that is funny?
A. I ain't going to be any more sadder than I ought to be. Might as well be cheerful about it.

There is no doubt that history was made in terms of American justice by the allowance of the Binet Scale in the Jean Gianini trial. Without the use of the test and the startling results, the jury very well might have sent Jean to the electric chair, and a mentally disabled boy would have been put to a gruesome death instead of receiving treatment in a mental health facility.

Alienists' Dossier

The trial of Jean Gianini featured the best alienists available on both sides. The alienists who were hired by the defense were Dr. Henry H. Goddard, Dr. A. Walter Suiter and Dr. Carlos MacDonald. The prosecution would bring in Dr. H.L. Palmer, Dr. Charles G. Wagner, Dr. Willis E. Ford and Dr. Charles W. Pilgrim. An interesting wildcard neutral alienist was Dr. Charles

Bernstein. Dr. Bernstein was not hired by the prosecution or defense, but he examined Jean and declared him an imbecile. It's highly unlikely that any trial in our day and age would have a group of the brightest experts in the world all descending on a small town like Herkimer, New York. The clash of the alienists was why the Jean Gianini trial was the trial of the century in Herkimer County. There could have been at least two more alienists on this list, but the defense decided not to call the two doctors it had waiting. This was due to the judge admonishing both sides for the length of the trial.

THE NEW YORK STATE SENATE CHIMES IN ON THE CASE

At the 138th session of the New York State Assembly, the legislative body weighed in on what it thought of the Jean Gianini case and high-grade imbeciles being allowed to roam free in the public arena. The session occurred in Albany, New York, in 1915 and addressed the need for rational treatment of public defendants. The senate stated that if a person is deemed feeble-minded and allowed to roam free without proper supervision, he or she will contract bad habits and commit crimes. The assembly cited Jean Gianini as having been committed to St. Vincent's School for Juvenile Delinquency in Utica and stated that he should have been properly diagnosed after being there approximately six months. He was admitted on August 18, 1913, and released only a month before murdering his teacher, Lida Beecher. The legislature referred to Jean as an "incorrigible half-orphan." The failure of St. Vincent cost a human life, and the senate stated that it could not happen again. The legislature noted that statistics didn't exist to track the number of crimes committed by irresponsible, weak-minded and epileptic people. It stated that one hundred years prior, Jean would have been treated as a normal young man.

Jean being found innocent because of being feeble-minded and a high-grade imbecile was cited by the New York State Senate as the first time in history a not guilty verdict was given due to the defendant being a "moral imbecile." The senate took the official stance that people like Jean should be placed in facilities for permanent custodial care and not receive life in prison. This was a big step in the diagnosis and treatment of those who should be treated for mental health issues and not thrown behind bars. The senate felt that the key would be to diagnose and treat those afflicted with such mental illness before another tragedy could occur.

Chapter 10

A Modern Look

The trial of Jean Gianini was more than one hundred years ago, and there have been numerous advancements in medical diagnosis and treatment of those who suffer from mental illness since that time. The justice system has also gone through adaptations and modifications in the last century. The death of Lida Beecher, the trial of Jean and the ultimate jury verdict and sentencing would be quite different in our modern age. The history of testing goes beyond the Binet Scale that was applied to Jean Gianini. His test has been deemed appropriate only in children, whereas there have been other tests developed for adults who were defended as "insane" in trials. The first in the United States was the M'Naughten Test, which first appeared in British courts in 1843 when a Scottish woodcutter, Daniel M'Naughten, murdered the secretary to the prime minister. His being deemed not guilty by reason of insanity outraged Queen Victoria, and a review of the details set the grounds that a defendant could not be held responsible for his actions if he could not tell that his actions were wrong when he committed them. This law would be honed when "irresistible impulse" was included as part of an insanity defense. This is when a person knows what he's doing is wrong but is unable to stop himself.

The laws determining legal insanity continued to be controversial, with many civil rights of the mentally ill being violated. Even today, many opinions vary on what determines legal insanity, and intrepretations are all over the map. Even members of Congress would call those who had been deemed legally insane "pampered criminals who kill with impunity." In

1984, Congress approved the Comprehensive Crime Control Act, which is still in use today. It states that a defense seeking legal insanity must provide clear and convincing evidence that at the time of the crime, the defendant was suffering from a severe mental illness.

When speaking to judges and prosecutors, one gets the opinion that the insanity defense is put out there quite a bit by defense lawyers, yet some legitimately mentally ill people might get convicted and placed in jail because of this tactic. Danny Cevallos, CNN legal analyst, criminal defense attorney and partner at Cevallos and Wong, says that the insanity defense is currently raised in less than 1 percent of criminal cases, and the ones found not guilty from insanity are committed to psychiatric centers for a lengthy amount of time. Cevallos explains the different types of modern insanity defenses, but the most interesting is that the terms are set by each individual state, and only forty-six have an insanity defense. Testing is done in forty-five states that can give a baseline and show irresistible impulse.

The success rate is so low on the insanity defense that in our age its use is almost nonexistent. Those people who are suffering from mental illness must not sit and rot in jail for life but must be able to be properly treated in mental health facilities. The defense is difficult and diagnosis is tricky, yet to completely ignore those in need is to ignore suffering souls.

Chapter 11

THE POEM

Jean Gianini wrote and left a poem in his jail cell after he was declared not guilty by reason of insanity. It was said that there were two poems, but one was too vile and obscene to be shown or published to the public. One can only imagine his thought process as he sat in his cell waiting for a train that would take him to Matteawan State Hospital for the Criminally Insane. Jean had been deemed a "high-grade imbecile," which means that he had some high-functioning thoughts yet still had those childish ones that had been classified as more consistent with those of a ten-year-old boy. Please keep that in mind when you read the poem written in his hand and left on the bench in his cell at the Herkimer County Jail. The one poem that was deemed appropriate for publication was printed in the Thursday, June 11, 1914 edition of the *Journal and Republican* of Lowville, New York:

Jean's Jailhouse Poem

My name is Gianini I would have you know.
And I always have trouble wherever I go.
To be thought a tough it is my delight.
And I'm thinking and planning both day and night.
I killed Lida Beecher with an old monkey wrench.
And they took me before the judge on the bench.

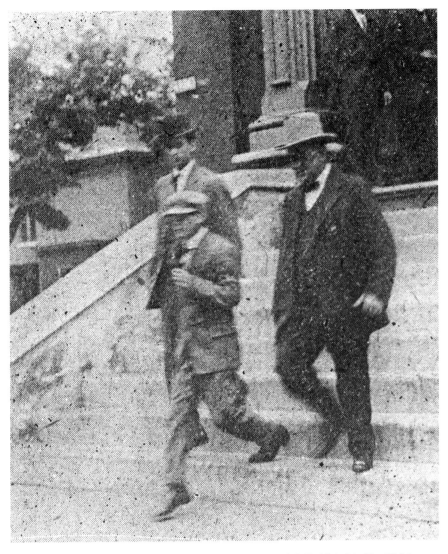

Jean Gianini leaving the courtroom on the last day of the trial. To his left is Sheriff Stitt, and to his right is Deputy Sheriff Hinman. *Courtesy Town of Russia.*

The sentence they gave me it caused me to smile.
It was "He is not guilty he's an imbecile."
Now here is thanks to the jurors who let me go free.
The foolishest men I ever did see.

The Shocking 1914 Case of a Vengeful Student

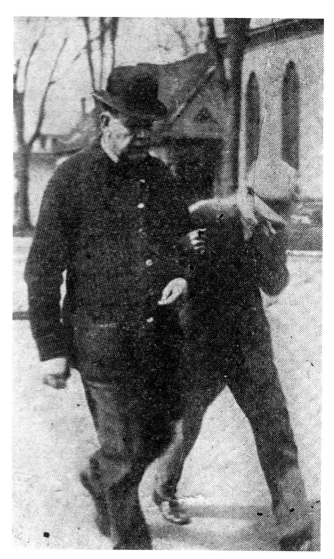

Jean Gianini being escorted by a law officer from Herkimer County Jail to the courthouse for his trial. His gait and way of walking would be involved in his defense. *Courtesy Town of Russia.*

When they came marching in it raised up my hair.
I thought sure they'd say "He must sit in the chair."
Now, soon I must leave you and bid you adieu.
And the dollars I've cost you won't be a few.
I never will fear if I can find McIntyre.
For I really believe he could save me from hell-fire.

—*Jean Martinette Gianini*

Chapter 12

FORGIVENESS

Lida's father, Reverend Dr. William A. Beecher, was a man of deep faith. He was the preacher at a small church in Lida's hometown of Sennett, New York. He came to Herkimer to retrieve his daughter's body and bring it back home for burial and funeral services. The night of his arrival, Reverend Beecher went to the home of Charles Gianini to speak with the father of his daughter's killer. The next day, Reverend Beecher went to the Herkimer County Jail and visited Jean. The reverend walked up and said, "I am the father of Lida Beecher. I thought you might want to speak with me. I have but a few minutes to speak with you but I wanted to know how you got her up that hill." Jean was open to the preacher coming into his jail cell. The reverend then went into the holding area, and guards stated that the two talked in private in Jean's cell and that the reverend held Jean's hand the entire conversation, yet no one was close enough to hear what the two discussed. Reverend Beecher only told reporters and others as he left that the conversation was private and he would not discuss the content, but he did say he forgave Jean for his crime.

People and the press were astounded at this soft-spoken, white-haired country preacher forgiving the boy who had murdered his daughter. The *New York Tribune* sent a sociological worker from the city to interview the gentle man to see how he could forgive such a crime. Boyd Fisher took the train to Syracuse and then continued on a short stint to the small town of Sennett, where he sat in the kitchen of Reverend Beecher's house and chatted about the crime, forgiveness and the vice of the young. Fisher

asked what was discussed when the reverend had visited Jean in his cell, and Reverend Beecher responded, "The boy has told me some things about how he murdered my daughter which he has told no one else and which is regarded as confidential. Unless he chooses to tell publicly all he knows, I shall not violate his confidences." Fisher was astonished that Reverend Beecher had forgiven Jean and showed him "bitter pity."

It was widely known that Lida had helped her pupil Jean on other occasions and had been murdered when she was again assisting the boy. Fisher described that when he was in Herkimer, citizens were whispering that the boy should be lynched, yet Reverend Beecher was forgiving the boy of the crime. Fisher described the reverend as a man with no thoughts of vengeance and stated that he went to Sennett to interview Beecher not out of curiosity but out of faith. He said he thought that he would find a saint, and he was not disappointed. Fisher was amazed that Reverend Beecher kept hate for Jean out of his Christian heart. Reverend Beecher said he loved Jean and said, "She [Lida] died as I would have her die. In the performance of her duty. She was betrayed and crucified, like the master, by those whom she served. I am sure some great good will come of it." Reverend Beecher used the term "the heroism of crime." Reverend Beecher paused, looked down at his kitchen table and muttered real low, "My daughter's death teaches its own lesson." The reverend said hundreds of people had written him prayers to offer God's grace to sustain him. The kind preacher then said to Fisher, "My daughter, however, was doing one more kindness to one who had often disappointed her. If she had been killed coming home from some dance or other frivolous amusement there would have been no inspiration for the world in her murder. But her death was a martyrdom such as God is continually regarding of us to save the world."

The Reverend Beecher paused while his lone living daughter removed dishes. Only after she was clear did he go back to addressing Fisher by saying, "Lida's pastor tells me that only the night before her death she attended a prayer meeting and led the service. He said he'll never forget her heartfelt words." Reverend Beecher went on to tell Fisher that the previous year had been difficult, as his brother, Reverend Willis Beecher, and two of his sisters had passed away, but Lida was by far the worst and heaviest loss. Fisher was astonished at the reverend's next words. The sociological worker/reporter asked how the holy man could find it possible to feel pity for Jean Gianini, and the reverend put his hand on Fisher's, looked him in the eye and said with iron in his words, "The boy is no different and no worse than boys right here in Sennett, and in every village and city in the country whose physical health

is weakened by cigarette smoking and other vices and whose imaginations are inflamed by motion pictures of crime and by cheap novels. As I looked at the boy, I saw behind him these influences, which I have always fought, and am still fighting, and I held them, not him, chiefly responsible." In those days, a boy who smoked cigarettes was considered the worst kind of person and a true criminal.

Fisher wrote in his article that the home of Reverend Beecher and the town of Sennett were in stark contrast to Herkimer, where Charles Gianini was spending his life savings to keep his son from the electric chair.

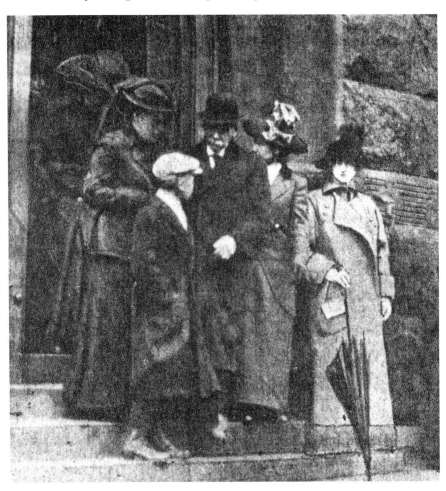

Lida's family arriving at the Syracuse train station after her funeral. *From left to right*: Mrs. Beecher, Judson Beecher, Reverend W.A. Beecher and good friend Ethyl Clark *(far right)*. *Courtesy Town of Russia.*

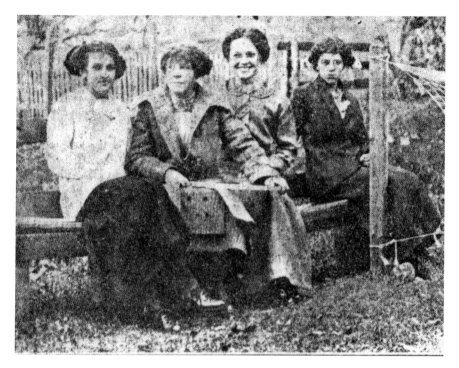

A happy and joyous Lida made many friends in Poland. *From left to right*: Olive Harvey, Frances Kreuzer, Lida Beecher and Miss Powell. *Courtesy Paula Johnson.*

He witnessed a town and jail swamped by alienists, lawyers, prosecutors, photographers and curious citizens, all of whom he said gave a "sensational atmosphere" to the town.

Reverend Beecher would see a prominent fellow preacher go against his forgiveness. The Reverend Dr. Parkhurst from New York City, who had been reported as eminent and divine, stated to the press that it was a sad and interesting case but that Jean's guilt was conclusive, as the boy had confessed, and that money was the defense and not insanity. "The insanity device has ceased to be original," said Reverend Parkhurst. "It has come as a kind of give-away. Human faculties may be roughly grouped into the mental, the moral and the spiritual. The spiritual does not concern us here. There remain the mental and the moral. It is freely conceded on every hand that that responsibility for one's act ceases with the cessation of mental sanity and that a lunatic is not accountable. But it is not always realized that in a similar way responsibility for one's act ceases with the cessation of moral sanity and that a moral pervert is no more accountable than a mental pervert, that

is to say than a mental lunatic." Reverend Parkhurst received front-page headlines with his views, but they were woefully inept and without any facts of the case in his possession. One has to side with Reverend Beecher, as he was the closest to one gravely lost. It's admirable that Reverend Beecher would find it in his heart to forgive Jean.

In the shocking aftermath of the decision to declare Jean not guilty by reason of insanity, Reverend Beecher slid a little bit in his forgiveness. In a moment of weakness, he expressed disappointment at the verdict and said that he had received letters saying one hundred men stood ready to take Jean from his cell and rip him limb from limb. Reverend Beecher said the entire affair had tested his Christian forgiveness. The reverend would always remain silent regarding his one-on-one conversation with Jean and never publicly rescinded his forgiveness of the boy.

Bibliography

Auburn (NY) Citizen. "Boy Is Indicted for Murder in First Degree in Killing Miss Beecher." April 3, 1914.
———. "Gianini Boy Confesses He Killed Miss Beecher." March 30, 1914.
———. "Motive for Crime." May 14, 1914.
———. "Now the Rebuttal." May 23, 1914.
———. "Pretty Slow Work in Jury Getting Today in Gianini Trial." May 8, 1914.
———. "School Marks Good." May 21, 1914.
———. "To Save Son's Life." May 16, 1914.
Buffalo (NY) Courier. "Defenders of Chicago Slayers Studying Famous New York Case of Gianini, 'Intellectual Imbecile.'" June 13, 1924.
———. "Employment of Alienists by Both Sides Promises Notable Legal Contest." April 12, 1914.
Buffalo (NY) Evening News. "Boy Murderer of Teacher Will Plead Insanity." March 31, 1914.
Cevallos, Danny. "Don't Rely on Insanity Defense." CNN, July 17, 2015. www.cnn.com/2015/02/11/opinion/cevallos-insanity-defense.
Cortland (NY) Standard. "John F. McIntyre to Defend Gianini." March 31, 1914.
———. "The Sworn Confession of Jean Gianini Is Admitted in Evidence." May 14, 1914.
Frontline PBS. "From Daniel M'Naughten to John Hinckley: A Brief History of the Insanity Defense." www.pbs.org/wgbh/pages/frontline/shows/crime/trial/history.html.

Bibliography

Gelb, Steven A. "Sentenced in Sorrow: The Role of the Asylum in the Jean Gianini Murder Defence." *Health & Place* 3, no. 2 (1997): 123–29.

Goddard, Henry Herbert. *The Criminal Imbecile: An Analysis of Three Remarkable Murder Cases*. New York: MacMillan Company, 1922.

Greene, Nelson. "Honorable Irving R. Devendorf." *History of the Mohawk Valley: Gateway to the West*. Vol. 3. Chicago: Clarke Publishing Company, 1925.

Herkimer (NY) Evening Telegram. "Again the Gianini Case." April 21, 1914.

———. "Girl Teacher Slain by Youth." April 5, 1914.

———. "Jean Gianini Is Morose at Matteawan." January 17, 1928.

———. "Jurors' Faces Are Hardened at Gianini's Confession." May 14, 1914.

Journal and Republican (Lowville, NY). "Jurymen Failed to Do Duty." June 11, 1914.

Legal Information Institute (LII). "Insanity Defense." www.law.cornell.edu/wex/insanity_defense.

New York Sunday Tribune. "Reverend W.A. Beecher Talks of Gianini." March 31, 1914.

New York Times. "Teacher Killed Had Befriended Him, Miss Beecher Was Trying to Have Gianini Admitted to George Junior Republic." April 1, 1914.

Perkins, Susan R., and Caryl A. Hopson. *Herkimer Village*. Charleston, SC: Arcadia Publishing, 2008.

Poland Bicentennial Committee (Ruth Gibson, Paula Johnson, Barbara Ozog, Evelyn Tudhope, Fran Kubick, Betty Hagan, Gertrude Johns and Steve Olney). *Poland, N.Y. Past & Present*. Poland, NY, 1976.

Post Standard (Syracuse, NY). "More Excused from Serving at Herkimer." May 6, 1914.

Rome (NY) Daily Sentinel. "Pilgrim Aids Prosecution." May 26, 1914.

———. "Prosecutor Grills Defense's Expert." May 19, 1914.

Rome (NY) Sentinel. "Funeral Services for Miss Beecher Held at Sennett." March 31, 1914.

———. "Gianini Testimony All In This Week." May 22, 1914.

Schenectady (NY) Gazette. "Jean Gianini Sentenced to Matteawan." May 29, 1914.

Senate of New York State Legislature 138th Session. "The Need of Custody for High Grade Cases." 30, no. 45, part 1. Albany, NY, 1915.

Skaneateles (NY) Free Press. "Jean Gianini Editorial Comment." June 5, 1914.

Steuben (NY) Farmer's Advocate. "Insanity to Be Plea." April 8, 1914.

Bibliography

Supreme Court of Herkimer County, transcript from stenographer's notes, vols. 1–12. The People of the State of New York v. Jean Gianini. Herkimer, NY, 1914.
Syracuse (NY) Herald. "Man Who Found Body of Lida Beecher Kills Self." December 26, 1914.
Syracuse (NY) Journal. "Boy Slayer Makes Clean Breast of Crime to Coroner." March 30, 1914.
———. "Button as Evidence Damaging to Defense." May 13, 1914.
———. "Famous Alienists of State to Be Called." May 18, 1914.
———. "Herkimer Court Stormed by Crowd of Morbid Women." May 16, 1914.
———. "Jean Gianini Knew What He Was Doing." May 22, 1914.
———. "Jurors Disregard County's Protest." June 26, 1914.
———. "She 'Snitched' So I Killed Her, Says Boy Slayer." May 19, 1914.
———. "Slain Girl's Bloody Garments in Court." May 12, 1914.
———. "State to Open Guns Upon Young Slayer." May 23, 1914.
Times Union (Albany, NY). "Rev. Beecher Denounces the Verdict." June 3, 1914.
Utica (NY) Daily Press. "Boy Is Held for Murder." March 30, 1914.
———. "Defense Closed Its Case Today." May 23, 1914.
———. "Did Not Know Exact Nature of Crime." May 22, 1914.
———. "Gianini Heard Murder Described." May 12, 1914.
———. "Jury Smarted Under Criticism." May 29, 1914.
———. "Selecting Jury Tedious Affair in Murder Case." May 8, 1914.
———. "Selecting the Jury in the Gianini Case." May 5, 1914.
———. "Waiting for the Verdict in Murder Case." May 28, 1914.
Utica (NY) Saturday Globe. "Queries Hypothetic." May 23, 1914.
Webster, Dennis. *Wicked Mohawk Valley.* Charleston, SC: The History Press, 2012.

Index

A

Adirondack Mountains 15
Albany, NY 15, 29, 33, 54, 70, 86, 122
alienists 25, 26, 38, 40, 43, 48, 72, 73, 83, 86, 89, 90, 92, 93, 99, 101, 104, 116, 120, 121, 122, 132
Auternrith, Jacob B. 77

B

Back, Peter 79
Beecher, Lydia "Lida" 9, 12, 19, 27, 30, 35, 36, 44, 48, 49, 50, 51, 52, 54, 58, 59, 60, 61, 62, 63, 64, 65, 69, 70, 71, 72, 73, 77, 78, 81, 83, 84, 85, 86, 87, 88, 89, 90, 91, 92, 94, 95, 104, 106, 109, 115, 121, 122, 123, 129
Beecher, William A. 27, 38, 39, 50, 91, 106, 129, 130, 131, 132, 133
Bernstein, Charles 26, 74, 80, 83, 84, 85, 93, 122
Betigny, Felicity 76
Binet Test/Scale 25, 43, 72, 74, 75, 84, 88, 90, 93, 94, 101, 104, 113, 117, 119, 120, 121, 123
Bockus, Charles 60
Brown, Grace 105, 106

C

Clark (Beecher), Ethyl 45, 49, 50, 51
Compo, Estes 59, 60
Coonradt, Elmer 90
Coonradt, Leo 59
Coon, William 77
Countryman, John 48, 53, 56
Criminal Imbecile, The (Goddard) 113

D

Davis, Lula 48, 78, 79, 85, 86, 89, 94
Devendorf, Irving R. 25, 26, 41, 47, 56, 94, 95, 96, 105
Douglas, Fred J. 61

E

electric chair 17, 21, 41, 43, 47, 51, 60, 62, 63, 70, 71, 87, 92, 93, 94, 103, 105, 106, 107, 109, 111, 117, 118, 121, 131

Index

F

Farrell, William E. 25, 40, 85, 93, 94
Fisher, Boyd 129, 130, 131
Fitch, Henry 44, 50, 56, 58

G

Gaffey, Henry 60
Gianini, Catherine "Moffie" 32, 38, 66, 67, 75, 78, 104
Gianini, Charles 32, 36, 37, 38, 39, 48, 49, 63, 64, 65, 67, 69, 70, 76, 77, 90, 103, 129, 131
Gianini, Charlie 32, 37, 67, 68, 75, 92
Gianini, Sarah "Sally" Cecelia (McVey) 32, 33, 37, 38, 66, 67, 68, 69, 75, 76, 81
Gillette, Chester 41, 63, 87, 103, 105, 106
Goddard, Henry 26, 43, 73, 74, 75, 80, 84, 92, 113, 115, 116, 117, 118, 119, 120, 121
Goodman, Alfred Y. 76
Graves, Henry 54

H

Hane, Charles 25, 39, 62, 63, 65, 66, 120
Herkimer County 15, 21, 36, 39, 40, 41, 47, 48, 60, 67, 80, 85, 86, 99, 104, 105, 106, 107, 109, 113, 122
Herkimer County Courthouse 26, 56, 65, 72, 75, 78, 82, 85, 89
Herkimer County Jail 64, 70, 74, 84, 89, 105, 109, 116, 119, 120, 125, 129
Hirsch, David C. 25, 39, 82, 91, 103
Howe, Morris 59
Hutchinson, Samuel 54, 58, 59

I

Ilion Citizen 104
imbecility 43, 66, 71, 72, 74, 75, 81, 82, 83, 84, 85, 86, 89, 91, 92, 93, 94, 95, 97, 101, 103, 104, 111, 113, 115, 116, 117, 118, 119, 122, 125

J

Jones, Arthur 33, 73
Jones, William 90
jury deliberation 93, 95

K

Kings Park Psychiatric Center 109

L

Lady Cliff Academy 33, 67
Lamb, Lawrence 56, 58
Larned, Lawrence 59, 86

M

MacDonald, Carlos F. 26, 43, 70, 71, 72, 73, 80, 81, 105, 119, 120, 121
Matteawan State Hospital for the Criminally Insane 35, 97, 103, 104, 109, 125
McIntyre, John F. 25, 36, 39, 40, 51, 52, 56, 63, 65, 82, 91, 92, 97, 99, 100, 103, 106
Miner, Anthony 73
M'Naughten Test 123
Moore, Fred H. 35, 62, 63

N

Nellis, John 35, 62, 63, 65
Newman, Anna 79
Newman, Frank 62, 77, 90
Newman, Horace 80
Newport, NY 15, 33, 49, 50, 60, 61, 62, 77, 87, 115, 116
New York Tribune 129

O

Onondaga Valley Academy 32

INDEX

P

Palmer, Charles 53
Palmer, Grace 52
Peterson, Fred E. 80
Pilgrim, Charles W. 26, 89, 90, 92, 121
Poland Central School 32, 33, 45, 50, 69, 77, 78, 83, 86, 90, 91, 94
Poland, NY 15, 17, 19, 25, 27, 32, 33, 35, 36, 37, 44, 45, 48, 49, 50, 51, 52, 53, 54, 56, 58, 59, 61, 62, 66, 67, 71, 78, 79, 86, 90, 93, 101, 113
Putnam, Angelica 75

Q

Quinlan, Frances J. 26, 67, 68

R

Robinson, Burt 77, 86, 87, 91
Russia, NY 11, 15, 35, 56, 63, 101, 109

S

Smith, William J. 54
Sprague, Arthur 19, 50, 58
Stanley, Mary 77
St. Anne's Sanitarium 33
Stitt, William H. 36, 62, 64, 65
St. Vincent's School for Juvenile Delinquency 33, 44, 50, 73, 79, 80, 87, 88, 90, 115, 116, 121, 122
Suiter, A. Walter 26, 41, 70, 71, 74, 80, 82, 92, 120, 121
Sweet, George 61

T

Thomas, Charles 25, 40, 41, 48, 49, 50, 51, 53, 56, 65, 72, 75, 82, 83, 91, 92, 93, 99, 100, 104, 107
Trask, Gertrude 52

W

Wagner, Charles G. 26, 86, 87, 88, 89, 92, 121
Weeks, Charles L. 26, 67, 69
Wilson, Sylvester 36, 62, 64
Wilt, Brainard 44, 45

About the Author

Dennis Webster lives and works in the Mohawk Valley of central New York. He has a bachelor of science degree from Utica College and a master's of business administration (MBA) from SUNY Polytechnic. He's a paranormal investigator with the Ghost Seekers of Central New York, a speaker and philosopher and is curious about the events of our world. His previous works include *Wicked Mohawk Valley*, *Wicked Adirondacks*, *Haunted Utica*, *Haunted Mohawk Valley* and *Haunted Old Forge*. He's the editor of and contributor to the bestselling Adirondack Mysteries series. He can be reached at denniswbstr@gmail.com.

Visit us at
www.historypress.net

This title is also available as an e-book